IMAGES
of America

HISTORIC
ELBERTON

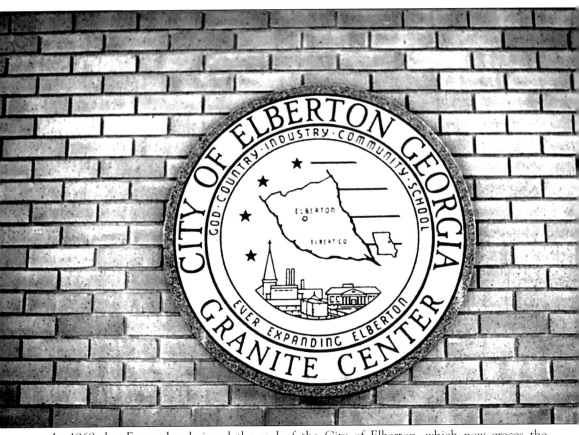

In 1969, Joe Fernandez designed the seal of the City of Elberton, which now graces the reception area of the City Hall of the Elberton Municipal Center.

IMAGES
of America

HISTORIC
ELBERTON

Joyce M. Davis

ARCADIA
PUBLISHING

Published by Arcadia Publishing
Charleston, South Carolina

Printed in the United States of America

Library of Congress Catalog Card Number: 2002107726

For all general information contact Arcadia Publishing at:
Telephone 843-853-2070
Fax 843-853-0044
E-mail sales@arcadiapublishing.com
For customer service and orders:
Toll-Free 1-888-313-2665

Visit us on the Internet at www.arcadiapublishing.com

To my sister Frances

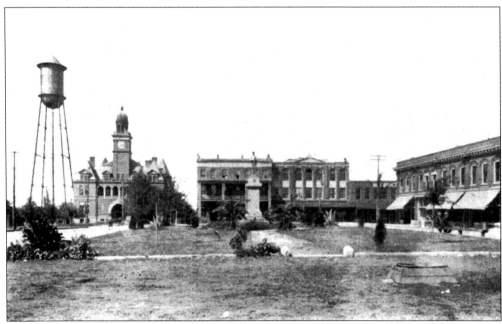

The public square in Elberton was still in formation around 1908, when (from left to right) the Elbert County Courthouse, Maxwell House, Opera House, Gairdner Building, and Day Block were new. The Day Block was completed in 1907 and filled immediately with merchants in the street-level storefronts and professionals in the offices above. (Courtesy of *The Elberton Star & Examiner*.)

CONTENTS

Acknowledgments 6

Sources Consulted 6

Introduction 7

1. Building the City of Elberton 9

2. Developing the Business District 29

3. Forging the Manufacturing Sector 55

4. Constructing a Grand Residential Community 71

5. Establishing Institutional Foundations 91

6. Creating a Travel and Entertainment Industry 109

7. Salute to Heroic Citizens 123

ACKNOWLEDGMENTS

I wish to thank many individuals for their assistance in the preparation of this book, for loaning materials, and for the provision of information. I wish to thank the following for special assistance and loan of materials: J. Paul Abernathy, Dr. McAlpin Arnold, Iris T. Anderson, Nicole and Jeff Bartenfeld, Phyllis Brooks, Rebecca Brooks, Mary Minor Hawes Brown, Stan Brown, Mrs. Allen Brown, Rosalyn Brown, Paula Bullock, Curtis Combs Jr., Cindy D. Churney, Sterling Daniel, Frances Davis, Rex Devane, Ted Dove, Ann and Harry Dunbrack, Chris Dyal, Teresa Eaves, Elbert County Historical Society, James C. Farmer, Jane D. Farmer, Katherine and Joe Fernandez, Wil Hall, Hailey Fortson, Judge Robert M. Heard, Rick Higginbotham, George Gaines, Mrs. James M. Hunt, Howard Hunt, Starke Jaudon, Peggy Johnson, Gary Jones, William A. Kelly, Charles Kinney, Bunnie and Stuart Lyle, Mary Maxwell, Shirley and Walter McNeely, Niles Poole, Sherri Rampey, Pat and Marvin Rathbone, Thomas A. Robinson, Mrs. Everett W. Saggus, Pegge Saggus Van Pelt, Albert T. Smith Sr., Mayor Iola Stone, Mary Thomas Thomason, Ret. Police Chief George Ward, Dr. Robert Patrick Ward, Police Chief Mark C. Welsh and the Elberton Police Department, Darlene West, Daryl West, Ronnie West, June and Tommy Westor, D. Scott Wilson and the City of Elberton Department, Barbara Winn, George Worley, Nadine Wright, and Mrs. Charles W. Yeargin.

SOURCES CONSULTED

Davis, Joyce M. *The Architectural Legacy of Elberton*. Elberton: The Elbert County Historical Society, 2002.

Early Cemeteries and Gravestones/Elbert County, Georgia: 1708–1919. Elberton: Elbert County Historical Society, 1984.

Elbert County Bicentennial Celebration. Elberton: Elbert County Bicentennial Celebration, 1990.

Elberton: 1909. Elberton: The Mayor, City Council, & Chamber of Commerce, 1909.

Elberton: The Granite City of Georgia. Elberton: *The Elberton Star*, 1913.

The Elberton Star, January 1891–April 14, 1999.

The Elberton Star & Examiner, April 21, 1999—June 2002.

Hunt, M.J. (ed). *History of the First Baptist Church*, Elberton: First Baptist Church, 1976.

Interviews with Dr. McAlpin Arnold, Mrs. Allen Brown, Mary Minor Hawes Brown, Stan Brown, Judge Robert M. Heard, William A. Kelly, Former Fire Chief Niles Poole, Pegge Saggus Van Pelt, Mayor Iola Stone, the late William T. Wallis, Former Elberton Police Chief George Ward, Elberton Police Chief Mark C. Welsh, City Manager Executive Assistant Barbara Winn, Elberton, 1989–2002.

Memoirs of Georgia. Atlanta: The Southern Historical Association, 1895.

McIntosh, James. *History of Elbert County Georgia: 1790–1935/With Supplement: 1935–1939* by
 Stephen Heard Chapter, Daughters of the American Revolution. Milledgeville: Boyd Publishing Company, 1966 (1940).

O'Neal, Phyllis Johnson. ed. *History of The United First Methodist Church*. Elberton: The United
 First Methodist Church, n.d.

Northern, William J. ed. *Men of Mark in Georgia*. Atlanta: A.B. Caldwell, 1911.

Wilcox, Herbert. *Georgia Scribe*. Atlanta: Cherokee Publishing Company, 1974.

Wilcox, Irene. "Thoughts to Share" Series, *The Elberton Star*, Elberton, June 1979–October 1988.

INTRODUCTION

In 1790, the Georgia Legislature created Elbert County and named it for Samuel Elbert (1740–1788), native South Carolinian and hero of the American Revolution, who moved to Savannah and later served as governor of Georgia (1785–1786). Elberton quickly became the seat of the newly created county and received its town charter in 1803. This city of rapid growth, strong civic consciousness, and architectural excellence is also renowned worldwide for a granite industry that grew from a small, 19th-century colony of stone carvers into the unified Elberton Granite Association, Inc.

Entrepreneurs, both native and adopted citizens, have included Dr. Nathaniel G. Long, who established the telephone system in 1894 and later expanded it to include outlying communities. By 1899, his system included 40 miles of telephone wire and was the largest system in the district, as well as the foundation for the later Southern Bell Telephone & Telegraph Company (now Bell South). Engineer Henry S. Jaudon moved to Elberton from Birmingham, Alabama, to mastermind the construction of the permanent waterworks system. The Harris-Allen Library of 1891 and Dave C. Smith's Opera House of 1892 introduced Elbertonians to special cultural and artistic achievements in the late 19th century. In the service field, Elberton also has been extremely progressive. The Georgia Sorosis of Elberton, founded by Mrs. E.B. Heard in 1892, for example, was the oldest federated club in the state and, as late as 1899, was the only affiliate of the organization in Georgia. *The Elberton Star* (now *The Elberton Star & Examiner*) has provided extensive and ongoing newspaper coverage since its foundation in 1888 and has been the most enduring of all newspapers published in the city.

Elberton experienced rapid growth in the late 19th century, following the introduction of railroad lines into the city. At that point, the unified architectural core of brick business blocks began to evolve around the rectangular public square at the city center and on North McIntosh Street close to the railroad tracks. From 1890 to 1920, the city began to take on its modern appearance; commercial growth in Elberton was rapid in the 30-year period from the 1890s to the late 1920s, as banks and stores appeared and prospered. In 1891, the city had 60 businesses and dwellings under construction, and growth continued at a fast pace during the next two decades. By the mid- to late-1920s, growth had reached a point at which commercial real estate in the city commanded high prices at resale. The growth also led to the construction of the only silk mill in the South and the first model, standardized Coca Cola Bottling Plant in the United States. Other new mercantile establishments included some major chain stores. Elberton, for example, was the first city of its size to open a store in the Woolworth's 5 & 10 chain. Also, the Gallant-Belk Company, a department store chain with stores in North and South Carolina, established its first Georgia store in Elberton in 1929, when it opened for business in the Almand and Wilcox buildings on the south side of the square. In Elberton, these new stores were part of the thriving economy of the rapidly expanding small city.

Residential expansion in major districts in the city reveals economic strength as merchants and professionals built and improved houses while their businesses prospered. Architectural styles of residences in Elberton have ranged from 19th-century Greek Revival and Queen Anne to 20th-century Neoclassical and modern, and have reflected stylistic and economic trends around the country.

By the 1930s, however, city growth began to ebb and came to a standstill after 1941, when the United States entered World War II. During this period, wartime restrictions on use of all materials prevented new construction and rebuilding of burned sites. Growth resumed in the late 1940s and continued in the 1950s at a moderate rate as new materials became available for peacetime usage and post-war optimism led to some new construction and replacement of architectural losses. By the early 1960s, however, city growth and new construction began to recede once more, with business and tax receipts lowered for the first time in decades.

The revenue decline for Elberton began to be reflected in population loss also, and these reductions came about as Elberton embraced the concept of shopping centers and created a bypass around the central commercial core of the city. Secondly, a national movement called Urban Renewal, designed to improve conditions in poor and under-developed sections of cities, improved some areas but created the unexpected effect in Elberton of isolating the mercantile district on the public square from potential shoppers. To improve city property, officials cleared away many old business and residential districts and built a bypass through the same cleared sections to make it easier to pass through the city. Elbert Street was widened to permit traffic to be diverted from the public square, and with fewer cars passing through it, the city itself, essentially, was passed by.

Economic decline continued during the 1960s and early 1970s, but restoration and preservation movements in the mid-1970s led to new interests in the revitalization of the business center. In 1976, the Elbert County Historical Society was formed; in 1991, the Elberton Mainstreet Program opened as a branch of the National Mainstreet Program founded in 1980 under the guidance of the National Trust for Historic Preservation. Some new population growth also has had an impact on the revitalization of the city. Altogether, throughout its 200 years, Elberton has reflected events, changes, and developments typical of small cities throughout America.

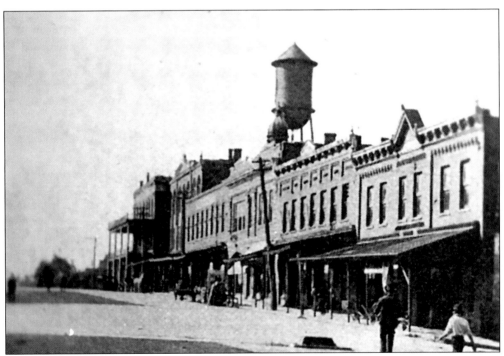

By 1909, the mercantile sector of Elberton continued its rapid growth on North Oliver Street. (Courtesy of *The Elberton Star & Examiner*.)

One

BUILDING THE
CITY OF ELBERTON

Some variation exists in how the beginning of Elberton is described, but the essence of the story of its early days is that settlers on their way from Virginia and North Carolina to establish towns in deep Southern states found a pleasant spot with a cool spring. Around this cool spring, the town of Elberton began to develop. In 1790, the Georgia Legislature created a new county from a section of adjacent Wilkes County and named it Elbert after American Revolutionary War hero and former Georgia governor Samuel Elbert. The practice of naming new counties after recently deceased prominent Georgians brought new recognition of the name Elbert at the time and has kept it alive during the two centuries of the city history.

The new seat of Elbert County had several names, including Elbertville, before it received the name Elberton. After becoming a county seat, the new community quickly grew large enough to become a chartered town. Thus, in 1803, the new town received its charter from the state and, by legislative act, was named Elberton. As the county seat, the town was extremely important and required a county courthouse. The courthouse that opened for business January 1, 1895, was the third permanent structure. Threatened by fire damage in 1964, however, and growth that could have led to a new building, the third courthouse designed by Reuben H. Hunt, was repaired and later revitalized by a new coat of paint in 2000. Because of strong city and county leadership, Hunt's building is still in service in 2002 as the courthouse of the county seat of Elberton.

The citizens of Elberton played equally important roles in establishing permanent sites for city and federal government functions. In 1897, the city government constructed a new city hall, which functioned until the late 1960s, when a new municipal center opened to house city government offices and the fire department. The new police department headquarters opened in 1971.

Leading citizens also played significant roles in appealing to the United States Congress for construction of a federal post office in 1914, a building that still serves the city, with only minor modifications. Elbertonians in positions of leadership in government and industry, past and present, have included Edmund Brewer Tate Jr., who, as chairman of the Elbert County Commission, persuaded the citizens of Elbert County to fund a new courthouse in 1894–1895. William O. Jones, a second prominent business leader, paid a debt to the community by serving on the board of education and working diligently to bring the new silk mill to the city in 1926. Other Elbertonians have lived in the city and left their marks, whether through the initiation by George H. Aull Jr., Charles M. Dixon, and Allen Brown of Elberton to government by a city manager, or the era of change with Iola Stone serving as one of the state's few female mayors. Throughout its 200 years, Elberton has been a city of hope and promise for all its citizens.

9

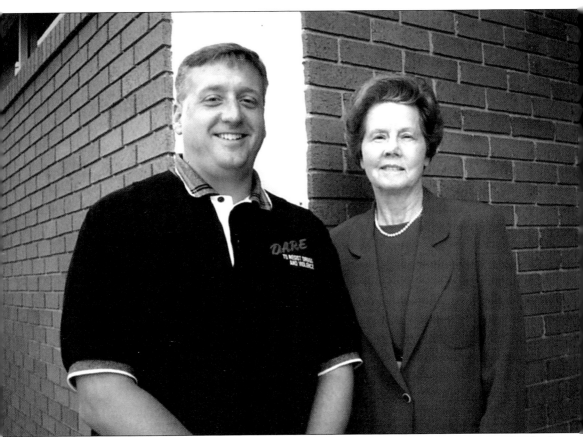

In 2002, Mayor Iola Stone (right) continues her groundbreaking tenure as civic head of Elberton while D. Scott Wilson (left) maintains a strong position as city manager of Elberton.

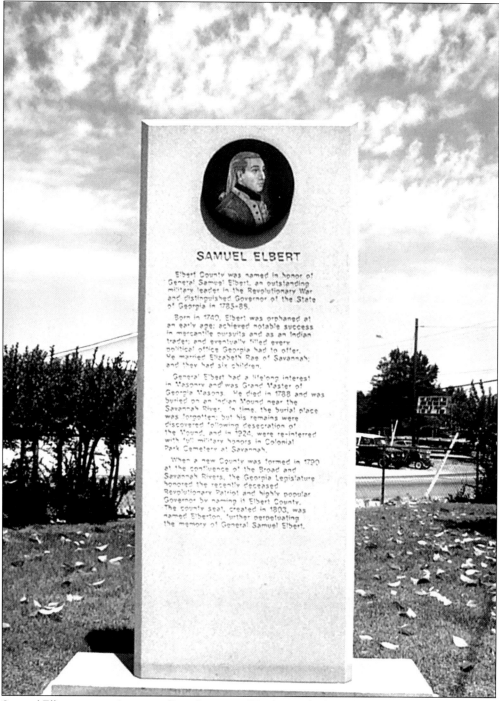

Samuel Elbert was an American Revolutionary War hero who later became governor of Georgia (1785–1786) and signed the bill establishing the University of Georgia. The monument pictured here was erected in 1992 by the Elbert County Historical Society and individual granite company owners at the old Seaboard-Airline Railroad Depot, which the society leased in 1989 for 75 years.

The first session of Elbert County Superior Court occurred January 20, 1791, six weeks after the creation of the county. It took place at the Thomas A. Carter plantation house on Beaverdam Creek, four miles from the city, with Judge George Walton, one of the signers of the Declaration of Independence, presiding. In this historic session, a man was convicted of murder and sentenced to be hanged on George Washington's birthday, a month hence. The 18th-century Carter house was only a temporary Elbert County court site and was replaced quickly by the first permanent courthouse constructed behind the present courthouse. The historic Carter House burned in 1968. (Courtesy of *The Elberton Star & Examiner*.)

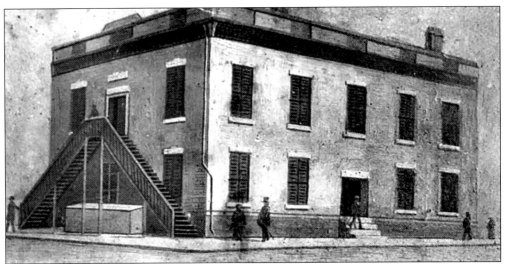

With new prosperity developing for the young city of Elberton, early 19th-century county officials constructed a second courthouse in brick in the center of the public square to replace the wooden courthouse. By 1893 this second courthouse building had deteriorated so extensively that *The Elberton Star* writers described the building as unsuited for continued use as the county courthouse. (Courtesy of *The Elberton Star & Examiner*.)

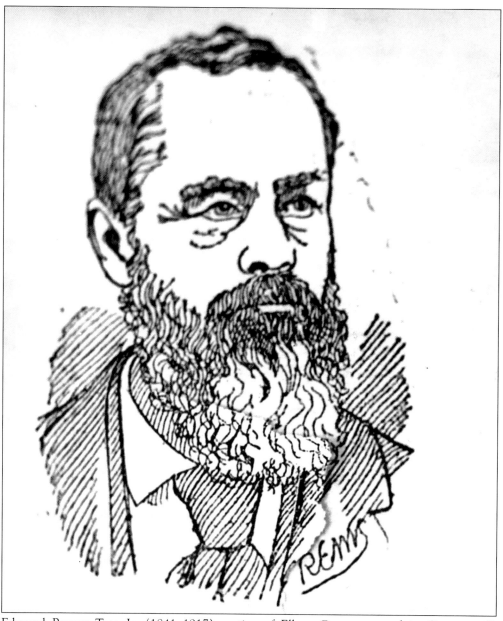

Edmund Brewer Tate Jr. (1841–1917), native of Elbert County, served in Company C, 15th Georgia Volunteers, under Capt. L.H.O. Martin, in the Civil War. He was wounded September 19, 1863, during the Battle of Chickamauga. For teaching service in the Elbert County field school at Asbury Chapel after the war, he earned $200 in gold, with which he built a substantial mercantile fortune. Later, Tate was elected to clerk of superior court (1866), ordinary (1868), and county commissioner of roads and revenue (1878). In his role as chairman of the Elbert County Commission, he played a major role in 1893 in persuading Elbert County citizens to fund the present Elbert County Courthouse. Construction began in 1894; the new courthouse opened in a formal ceremony January 1, 1895. (Courtesy of *The Elberton Star & Examiner*.)

In 1893, Reuben Harrison Hunt (active 1890s), Elberton native and senior member of the Hunt & Lamm Architectural firm in Chattanooga, Tennessee, won the competition to design the new Elbert County courthouse. *The Elberton Star* published the engraving of Hunt's design soon afterward. (Courtesy of *The Elberton Star & Examiner.*)

L.L. Stephenson (1867–1948), a native of Covington, Georgia, arrived in Elberton in 1893 to serve as contractor of the new Elbert County Courthouse. He later moved to Birmingham, Alabama, in 1900 and died in 1948 while visiting his daughter in Atlanta. (Courtesy of *The Elberton Star & Examiner.*)

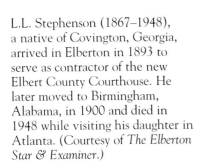

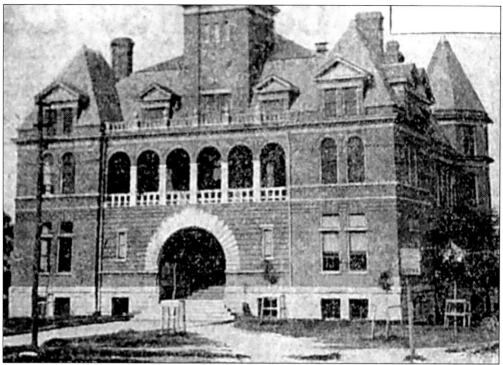

In his design for the third and present courthouse of Elbert County, architect Reuben H. Hunt employed the Richardsonian Romanesque style of Henry Hobson Richardson. (Courtesy of *The Elberton Star & Examiner*.)

Reuben H. Hunt's design for the Elbert County Courthouse included many common features of the popular, Richardsonian Romanesque style, including a massive, round-arched entrance defined by prominent granite voussoirs and the superimposed round arcade visible here.

15

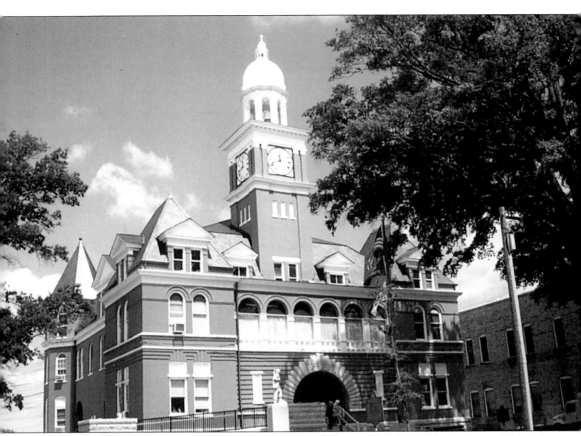

In the late 1950s, Elbert County officials painted the red brick courthouse gray. Then, in 2000, county officials painted the brick surface red so that it now closely resembles the original appearance of the brick building.

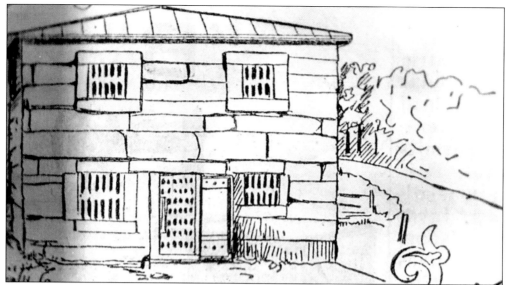

An early Elbert County jail was built about five or six years following the end of the Civil War after the old wooden jail on the public square burned. Although this jail was a big improvement over the old wooden one, by 1893 after 20 years of usage, it too had become dilapidated and insufficient for incarcerating prisoners. One newspaper writer described the rock and mortar jail as inadequate to prevent prisoners from escaping, joking that a prisoner could almost break out with a toothpick. (Courtesy of *The Elberton Star & Examiner*.)

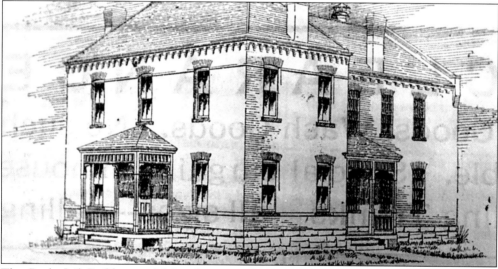

The Pauly Jail Building and Manufacturing Company of St. Louis, Missouri, premier jail builders in the United States at the time, constructed a new jail with hardened steel cells from 1893 to 1894, at the cost of $10,000. The primary jail units on the second floor consisted of 6 cells with a possible accommodation of 24 prisoners, although the company recommended a maximum of 12. The building also included living quarters for the jailer on the ground floor. This jail has been replaced by the Elbert County Detention Center of 1992, but it remains extant and includes an annex added in 1937 by H.J. Price and the Daniel Construction Company. Today the building houses the magistrate court of Elbert County and office of chief magistrate. (Courtesy of *The Elberton Star & Examiner*.)

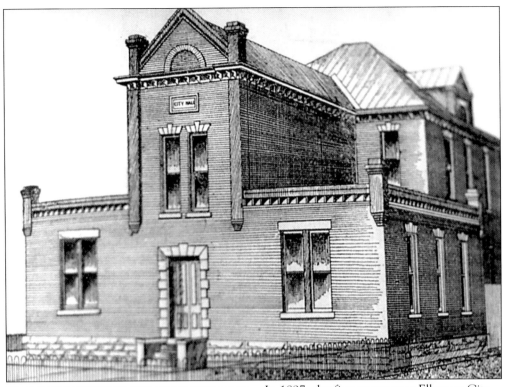

In 1897, the first permanent Elberton City Hall was constructed on North McIntosh Street at the cost of $5,000. The completed brick building varied from this published design, which appears to show a wooden frame structure. The city hall that was constructed is a much larger brick building than the one shown in this print. (Courtesy of *The Elberton Star & Examiner*.)

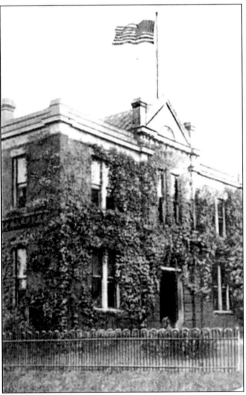

The classical features of the city hall as built in 1897 soon became covered with ivy, which enhanced it with an almost ivy-league character and created an image of attractiveness and high purpose in the rapidly expanding city. It included a new jail that replaced the city lockup, which, like that of the county, had been considered an eyesore to the community for some time. (Courtesy of Ted Dove.)

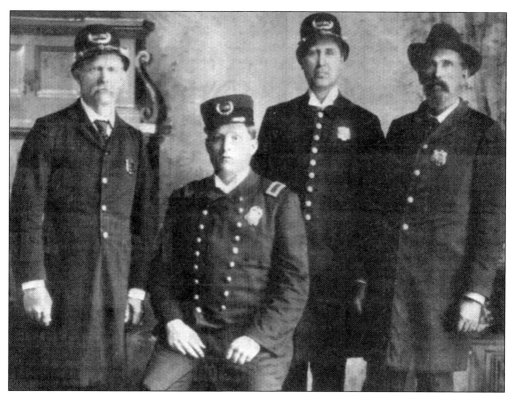

In 1898, the police force consisted of, from left to right, Officer W.H. Irvin Sr., Police Chief W.H. Irvin Jr., Officer Tom Jones, and Officer Pless Hamm. (Courtesy of Elberton Police Department.)

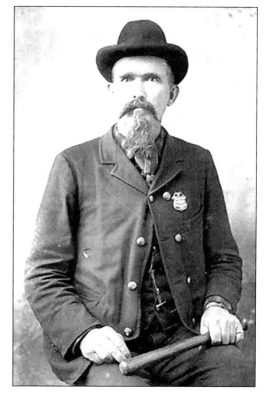

Police Officer Pless Hamm poses for the camera around 1900. He is remembered fondly as one of the major figures in the city at the time by James McIntosh in his *History of Elbert County Georgia 1790–1935*. Pless's family donated the nightstick he is holding here to the Elberton Police Department. (Courtesy of the Elberton Police Department.)

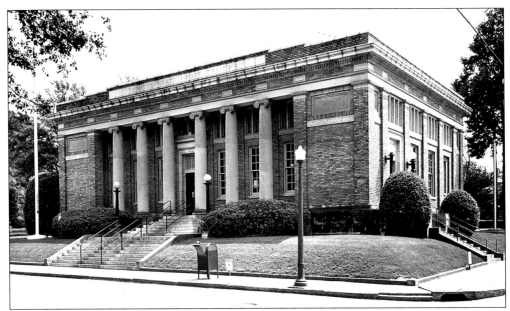

In December 1908, federal representatives announced the site of a new post office on the southeast corner of Heard and Thomas Streets. With federal funds, it was constructed of yellow brick rather than granite, after Elbertonians discovered that the granite was not from Elberton. The new federal building opened in March 1914, and with only some minor additions, is still in use in 2002. (Photograph by Everett W. Saggus, Courtesy of Shirley and Walter McNeely.)

The Fire Department of Elberton began as a voluntary unit that was close to that of a social club. The force listed in *The Elberton Star* in March 1921 included, from left to right, Assistant H.V. Pleasants, Firefighter Brewer Jones, Assistant B.V. Maxwell, and Assistant G.S. Bullard. Chief Henry Snellings was not present. (Courtesy of *The Elberton Star & Examiner*.)

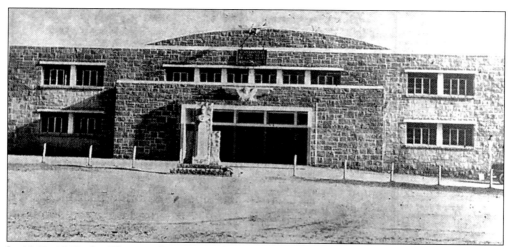

In 1940–1941, the Elberton City Council, with funds from many sources, including the Works Progress Administration of President Franklin D. Roosevelt, built a granite Armory Auditorium constructed with load-bearing walls for the 122nd Infantry of the Georgia National Guard. Local architect Hunter J. Price designed the building, which is decorated with a large granite phoenix carved in the Art Deco style on the facade. In later years, the Armory Auditorium was used for high school basketball games and Elbert County Chamber of Commerce banquets. Then, after years of non-use, Dr. Alice Terry, teacher of the gifted and talented class challenge of the Elbert County Middle School, and her students led a successful effort to achieve a nomination on the National Historic Register on December 31, 1998, which was announced by *The Elberton Star & Examiner* January 20, 1999. (Courtesy of *The Elberton Star & Examiner*.)

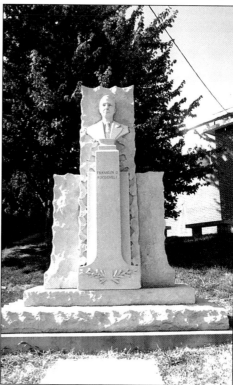

A statue of President Franklin D. Roosevelt, whose Works Progress Administration program partially funded the 122nd Armory Auditorium in Elberton, appears in a granite monument characteristic of how the physically disabled president was portrayed during his lifetime. The monument, which has been moved to the southeastern corner of the Elbert County Middle School grounds, was begun by one artist in 1939 and completed by Richard Cecchini in 1941. Its restoration in 1995 by Dario Rossi was part of the project initiated by Dr. Alice Terry and her students.

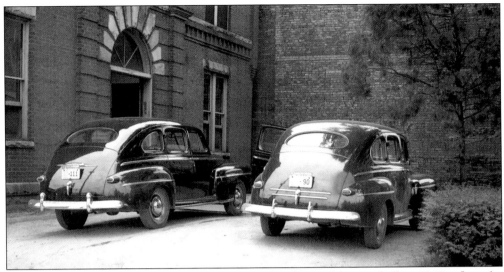

The 1947 and 1946 model Ford police cars parked in front of the city hall in 1948 reflect the change from horse-and-buggy days of 1897. (Courtesy of Elberton Police Department.)

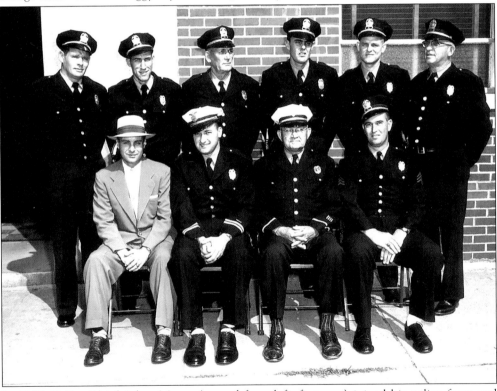

In 1955, Police Chief Adger Moore (second from left, first row) joined his police force and the first City Manager George H. Aull Jr. From left to right are the following: (front row, seated) City Manager Aull, Police Chief Moore, Assistant Police Chief Hugh Cleveland, and Officer Gene Bryson; (back row) Walter Bagwell, Frank Stratton, W.H. Lovin, Herbert Smith, George Ward, and Roscoe Echols. (Photograph by Everett W. Saggus, Courtesy of Shirley and Walter McNeely.)

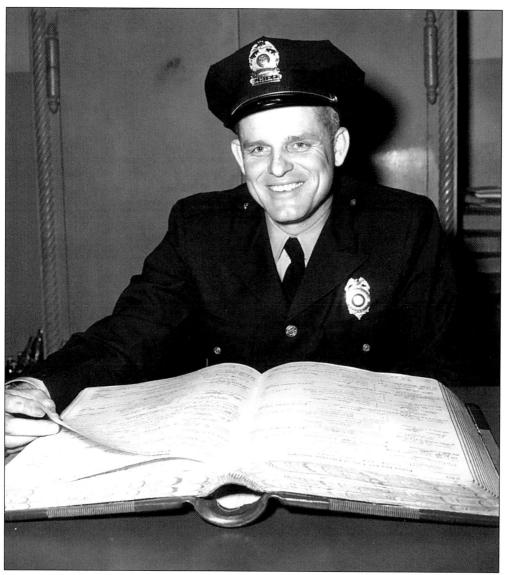

George Ward joined the police department as a patrolman in 1952. Later he became sergeant and, then in 1957, he was appointed police chief, an office he held until his retirement in 1993, after 41 years of service. Here, young police officer and future Chief of Police Ward looks over the police blotter. In 1962, Chief Ward attended the FBI Academy for an invitation-only training program, which was capped by the speech of President John F. Kennedy at the graduation service. In 2002, retired Chief Ward, who received many service awards during his tenure in the police department, is being honored by The Georgia Association of Chiefs of Police, Inc., which he helped found in 1962 and which named him Outstanding Chief in 1976. (Photograph by Everett W. Saggus, Courtesy of Shirley and Walter McNeely.)

James Mathews Hunt (1915–1993), a native of Elberton, returned to the city after military service and almost single-handedly defined the modern style of new buildings in the city. (Courtesy of Mrs. James M. Hunt.)

In the late 1960s, James M. Hunt designed a new Municipal Center consisting of city hall and the fire and police Departments. Funding came slowly, and Hunt's plans were reduced. The city hall and fire department opened in 1968, and the police department opened in 1971.

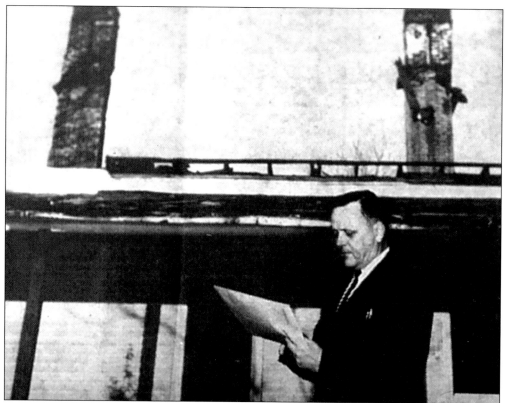

In 1968, Dr. John B. O'Neal III (1920–1993), led the Elberton Civic Center Committee Inc. to build a new civic center on a lot on College Avenue donated to the city by the Seaboard-Airline Railroad. O'Neal spoke at the dedication of the center, noting that it was for the use of all citizens and invited everyone to visit and use the center. Here, he consults building plans at an early stage in the project. (Courtesy of *The Elberton Star & Examiner*.)

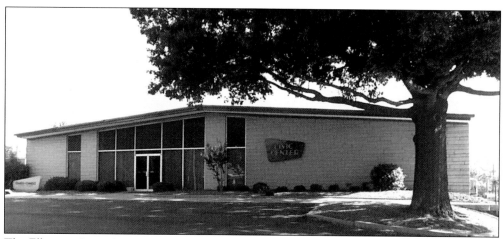

The Elberton Civic Center opened in 1968. It is now the home of the Elbert County Chamber of Commerce and the community center for civic, business, and cultural organizations' regular meetings, as well as special occasions.

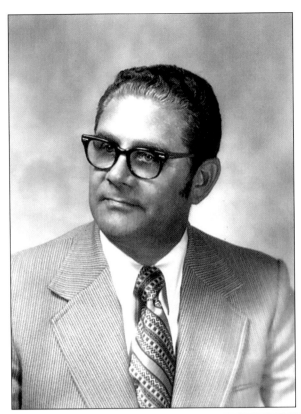

Allen Brown (1924–1988) worked in city government for 31 years and served 26 of those as the third city manager before retiring in 1986. His accomplishments included Urban Renewal projects and the City Utility System. In 1989, the Elberton Bar Association paid tribute to Brown's service by granting the Liberty Bell Award to him posthumously. (Courtesy of Mrs. Allen Brown.)

Niles Poole joined the fire department as a firefighter in 1955 and became chief in April 1972. He served as fire chief until his retirement in 1998. (Courtesy of Niles Poole.)

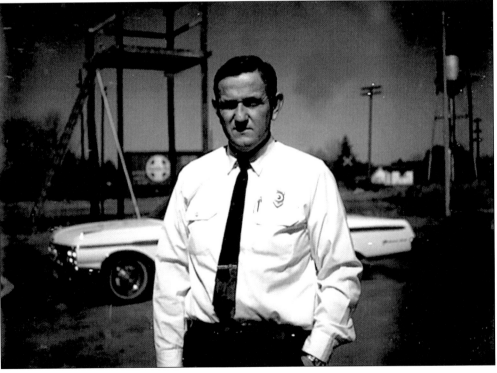

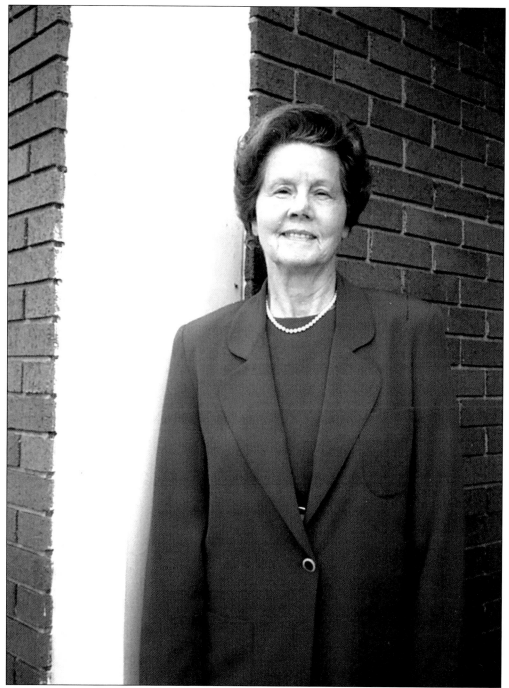

In January 1994, Iola Stone became mayor of Elberton and continues in the elected executive position until the end of her term in December 2005. Mayor Stone has brought significant skills of governance to her tenure as mayor. Her honors and awards are numerous and attest to the esteem in which she is held by professional peers, as well as by her constituents in the City of Elberton.

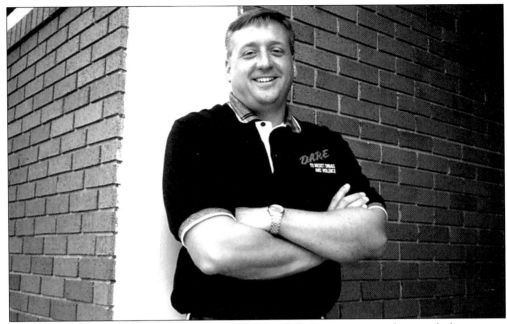

City Manager D. Scott Wilson was hired by Mayor Iola Stone to serve first as clerk-treasurer and finance director and then city manager, a position in which he continues to serve. In addition to managing his busy schedule as city manager, Wilson also provides the valuable service as treasurer of the Elbert County Historical Society.

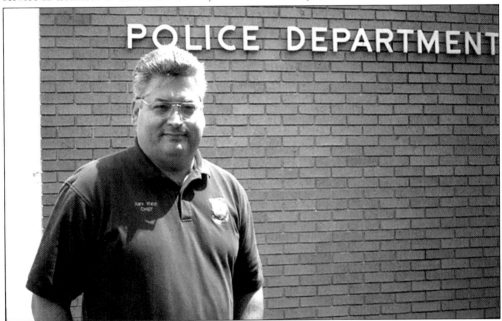

Mark C. Welsh came to Elberton from the metro Atlanta area to become police chief in November 1998 and continues to serve the city in this capacity in 2002. An amateur photographer, Welsh also has captured images of numerous Elbertonians by reprinting photographs from vintage negatives left in the photography studio shared successively by J.H. Orr, Nathan D. Taylor, and Everett W. Saggus.

Two

DEVELOPING THE BUSINESS DISTRICT

After receiving its charter in 1803, Elberton began to grow slowly as a commercial center. By the end of the 19th century, however, the growth had accelerated rapidly, and storefronts were filling with new businesses in buildings around the public square and on North McIntosh Street. Many of the businesses occupied stores in the Swift Block on the eastern side of North McIntosh Street and other storefronts on the western side, as well as stores in the block beyond Elbert Street leading to the railroad tracks. This growth northward toward the railroad was envisioned earlier by Dr. Nathaniel G. Long, who expanded the street toward the railroad by building business blocks on both sides of North McIntosh Street. In the process, he took businesses right up to the tracks. The merchants in the North McIntosh district thus were in an optimum position to take advantage of rail transport of goods.

A number of noted merchants were also civic leaders responsible for encouraging the improvement of the town with the construction of better city and county facilities and for upgrading their own private mercantile properties. Among these was William Augustin Swift (1806–1856), a prosperous merchant who built a block of stores, including the building housing his own store on the northeast corner of the public square and North McIntosh Street. Swift and his bride, Nancy J. Kellar Swift (1818–1919), living in an apartment above their store, reared a family that included their eldest son Thomas, who, with his younger brothers, subsequently improved the original wooden store buildings in the Swift block on North McIntosh Street. Other major business leaders included McAlpin Arnold, W.M. Wilcox, Edmund B. Tate Jr., H.K. Gairdner, William O. Jones, the Duncan Brothers, the Brewer family, and the Brown Brothers.

In 1888, Thomas M. Swift Sr. also established the Elberton Loan & Savings Bank, the first bank in the city, which survived until the early 20th century. Swift's banking competition came from the Bank of Elberton, established in 1893 and closed in 1926, and the First National Bank, which opened in 1908 and is still functional today under the name Pinnacle Bank. In 1928, the newly formed Granite City Bank opened for business and continued to function until it became part of the Regions Bank group. In addition, for a short time, the Citizens Bank and the Elbert County Bank served the citizens of the city and the county. A recent entry in the Elberton banking industry is the Northeast Georgia Bank. A second type of financial institution now part of Elberton's history is the Elberton Building and Loan Association, which opened in 1922 after selling stock shares to fund the endeavor. The association still survives under the name Elberton Federal Savings & Loan Association in a building constructed in 1966.

Both mercantile enterprises and the banking industry in Elberton engendered financial prosperity for the little city built around the cool spring in the 18th century. The story of the bankers and mercantile leaders is the story of the city itself.

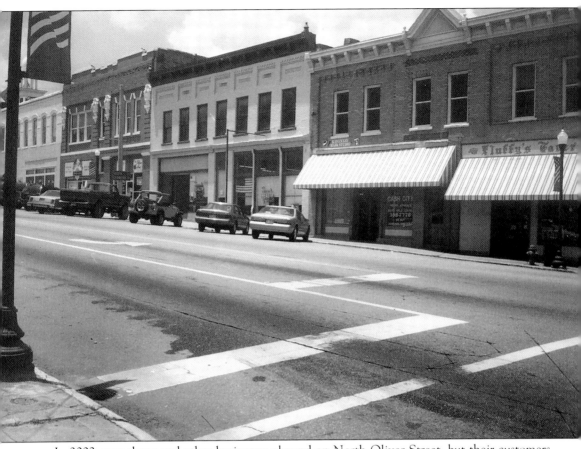

In 2002, new shops and other businesses abound on North Oliver Street, but their customers drive to these destinations, rather than walk, as they did in 1909.

Thomas M. Swift Sr. (1847–1932), eldest son of William A. and Nancy J.K. Swift, returned to Elberton from the Civil War and soon afterward took his savings of $2,000 to transform his inheritance into a profitable business organization. He rebuilt in brick the entire block of wooden stores his father had begun and amassed an enormous fortune in the mercantile business and a variety of other ventures. He also followed the example set by his parents and engaged in charitable acts. One public example occurred on the coldest of winter days when Swift used his wagon to transport food and other necessities to more than 200 citizens throughout the city—and reported that it was one of the happiest days of his life. (Courtesy of *The Elberton Star & Examiner.*)

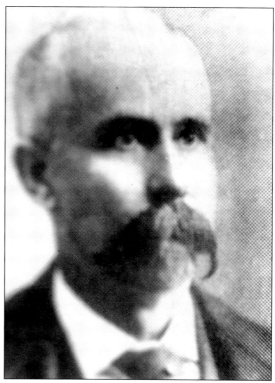

Police Chief Mark C. Welsh made this photographic print of Thomas M. Swift Sr. from negatives left in the old photographic studio rented first by J.H. Orr and then by Nathan D. Taylor and Everett W. Saggus. The author, based on the correlation with documented images of Thomas M. Swift Sr., makes the identification of him here. (Courtesy of Police Chief Mark Welsh.)

31

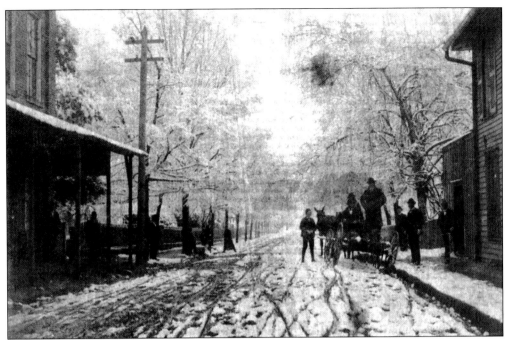

By the 1890s, W.M. Wilcox was renting the brick storefront building Thomas M. Swift Sr. had built to replace the wooden Swift store building that burned. On a snowy day, Elbertonians sought shelter in Wilcox's store on the left and in the Jones & Co. Store on the right. (Courtesy of *The Elberton Star & Examiner*.)

In 1925, Thomas M. Swift Sr. modernized his old brick store building on the northeast corner of the public square and Heard Street by covering it with a stucco surface. Interior Designer Susan Puleo painted the building Tuscan Red, for a recent private project that did not succeed.

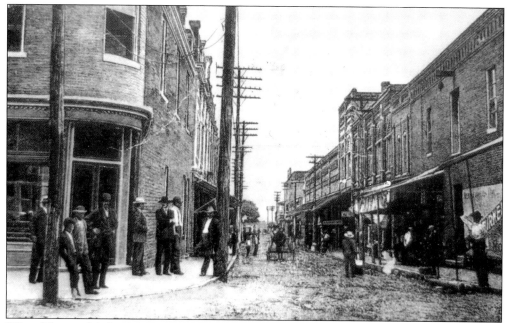

When Thomas M. Swift Sr.'s wooden storefront buildings burned, he replaced them one by one with brick structures that are still standing today. Intricate decoration adorns these buildings visible in a postcard made at some point between 1896 and 1919, the period during which the Bank of Elberton building at the left was located in this spot. (Courtesy of Ted Dove.)

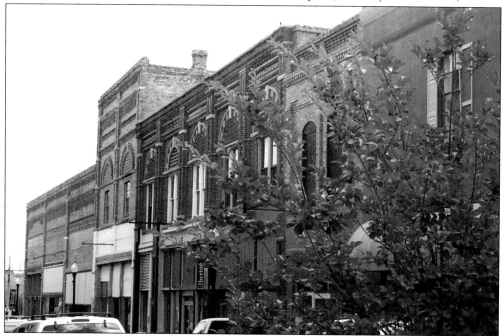

Distinctive arrangements of notable brickwork in the storefronts in the Swift block on North McIntosh Street resemble quilt patterns in some cases, and African triangular designs in others lend credence to an unproved and little-known oral legend that the brickwork was the artistic product of uncredited African-American artisans.

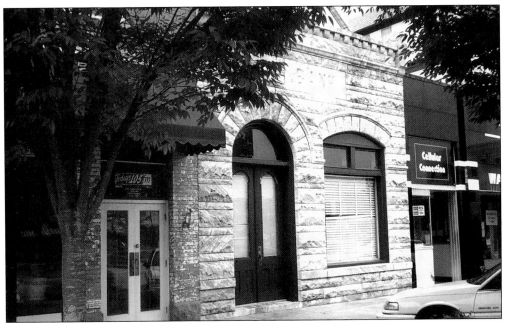

In 1893, the Bank of Elberton opened with a capital of $25,000 in a small, marble-faced, Richardsonian Romanesque building on the south side of the public square. Officers included Pres. McAlpin Arnold, Vice Pres. T.O. Tabor Sr., Cashier L. Martin Heard, and Assistant Cashier J. Blackwell. In 1896, when the bank constructed a new building on the opposite side of the square, jeweler F.G. Trefzer caused an uproar in town. Trefzer, who had placed a bid on the 1893 building, demanded that bank officials be out of the building by noon on September 1, leading Cashier Heard to set up a desk in the street and continue business as usual. Trefzer, for reasons not made clear in newspaper accounts, did not complete his purchase of the bank building. The bank soon moved into its new structure across the street. Dr. A.S.J. Stovall was a later owner of the 1893 building.

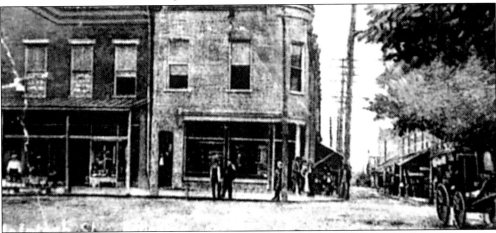

In 1896, the Bank of Elberton moved into its new building on the northeast corner of the public square shortly after F.G. Trefzer forced the staff to move the bank furniture and equipment into the street. The new site opposite the Swift block was a popular one for gatherings of citizens. This bank stood for more than 20 years until the bank constructed its replacement, which still survives on the spot. (Courtesy of Ted Dove.)

McAlpin Arnold (1847–1912), who appears in the group of cotton buyers on the cover, was a native of Elbert County who served in the Civil War and later rose to prominence as a business and civic leader in Elberton. In 1874, he formed a partnership with Thomas M. Swift Sr. that he dissolved two years later to begin a long period of association with H.K. Gairdner. With Gairdner, he operated a business in the Arnold building until 1909, when he sold his portion of the business to his brother W.T. Arnold and retired. McAlpin Arnold also served as president of the Bank of Elberton, which opened in 1893 on the public square, and later president of the Citizens Bank that operated briefly on the eastern side of the square. Arnold was also president of the Commercial Cub, which was organized in Elberton in 1905 as the first commercial organization in the city. (Photograph by J.H. Orr, Courtesy of Dr. McAlpin Arnold.)

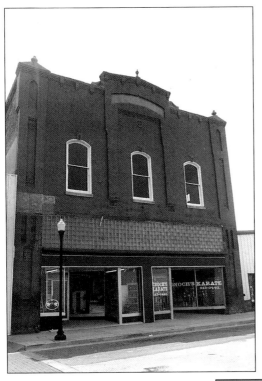

The late 19th-century Arnold building has served as site of Arnold family businesses under a variety of names, including Gairdner, Arnold & Co. (that reflected McAlpin's partnership with H.K. Gairdner before the latter's death in 1899.) W.T. Arnold & Son replaced the Arnold & Co. name that followed later. The name changed to W.T. Arnold & Sons, after McAlpin's brother W.T. purchased the business and added his sons to the company. The Arnold Building, which is extant and almost unchanged, is notable for its remarkable decorations, including lion head keystones in the upper windows.

Dr. McAlpin H. Arnold, grandson and namesake of merchant and cotton buyer McAlpin Arnold, served the community of Elberton during his medical career until his recent retirement and has remained active in civic activities in Elberton.

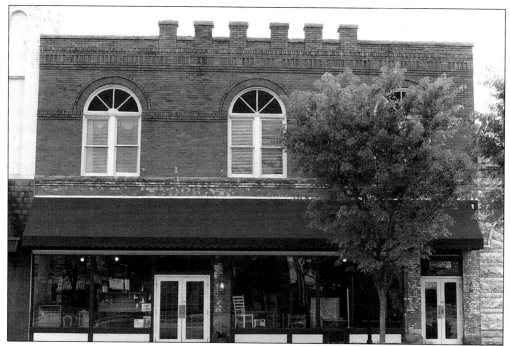

Dr. Alfred S. Oliver, like other doctors in Elberton, entered the mercantile business and, in 1897, constructed a large storefront building on the south side of the public square, which served as site of one of the early post offices and *The Elberton Star* in the offices upstairs. In the late 1990s, Don Fortson purchased and renovated the building.

In 1895, John C. Brown built a new storefront on the site of the old jail lot on the southwest corner of College Avenue and Oliver Street, which he purchased from James McIntosh. Elbertonians were delighted that Brown had improved the unsightly corner where the deteriorated old rock jail had stood until a short time before. John C. Brown and his brothers Dilliard and Mallory operated the store as Brown Brothers, and later the name became Brown Brothers & Sons. The store, which sold a variety of high-quality goods, remained popular for many years and is remembered fondly today by senior citizens.

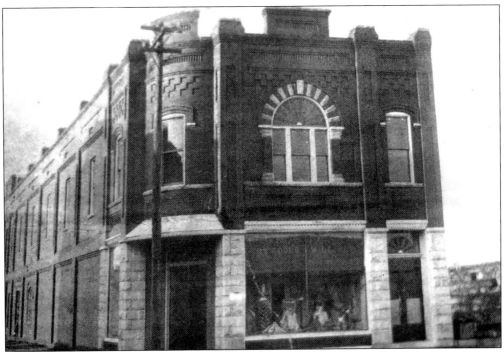

W.C. Smith moved to Elberton in 1880 and entered the rapidly developing mercantile market with a general merchandise store he operated first with his brother Dave C. Smith as W.C. Smith & Brother and then with his son as W.C. Smith & Son. In 1881, he purchased a large, long lot on the southeast corner of the public square from Joseph P. Deadwyler and built a storeroom, which burned in May 1899. Smith's store was so successful, however, that a destructive fire could not destroy his business, which he reopened very quickly in September in a brand new building. The store and location soon became a familiar city landmark known affectionately as Smith Corner. (Courtesy of *The Elberton Star & Examiner*.)

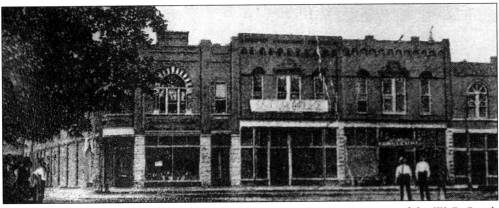

In the fall of 1900, C.J. Almand and W.M. Wilcox opened new stores west of the W.C. Smith building on the south side of the square. The beautiful interiors, which contemporary newspaper writers described, were considered critical elements of the commercial success of stores in 1900. Also, the elaborate ornamentation on the exterior of the buildings, including cartouches or decorative shields encasing the date "1900" over both buildings, were part of the total image merchants presented to the buying public. (Courtesy of Elbert County Historical Society.)

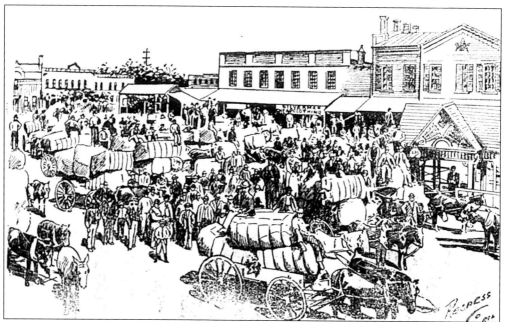

Cotton production and sales constituted a significant portion of the economic base of Elberton and Elbert County a century ago. Cotton growers in the county transported their cotton in wagons to the public square in Elberton, where major merchants examined the cotton by cutting into the bales to judge the quality of the cotton and determine the price paid to the growers. On a Cotton Sale Day in October 1895 recorded in *The Elberton Star*, more than 500 bales of cotton came into Elberton on wagons from Hart, Elbert, Madison, Oglethorpe, and Wilkes Counties to be purchased directly from the growers who had brought them. (Courtesy of *The Elberton Star & Examiner*.)

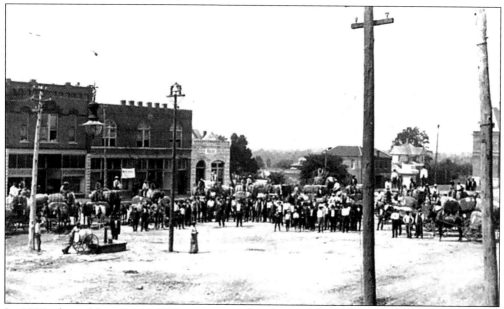

In 1902, the public square of Elberton provided the background setting for a day of Cotton Sales. (Courtesy of *The Elberton Star & Examiner*.)

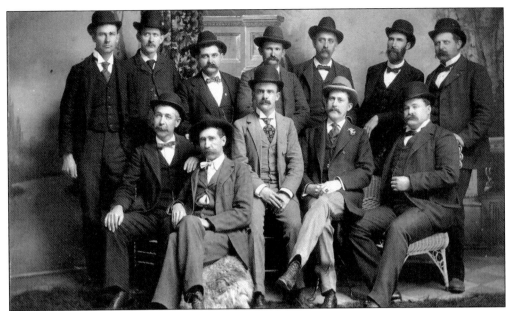

Some of the leading city merchants who purchased cotton on the public square in Elberton posed for a group portrait in J.H. Orr's studio about a century ago. Featured here from left to right are the following: (front row) W.T. Duncan, an unnamed buyer presumed to be from out of town, W.E. Snowden, W.O. Jones, and S.O. Hawes; (back row) J.E. Asbury, E. Lucius Adams, W.F. Anderson, Jesse J. Warren, McAlpin Arnold, T.O. Tabor Sr., and J.C. Brown. (Photograph by J. H. Orr, Courtesy of Dr. Robert Patrick Ward.)

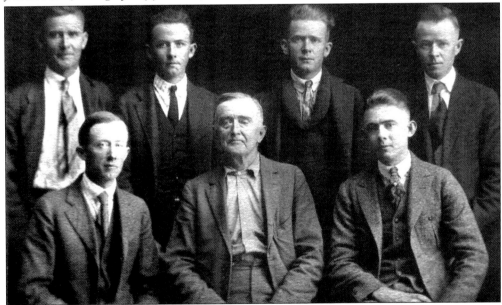

The Pam Daniel family belonged to the legion of cotton growers who brought their cotton to the market on the square for sale. The male members of the family included here, from left to right, are as follows: (front row) Bud, patriarch Pam Daniel, and Ben; (back row) Brooks, Jud, Miller, and Henry. The photograph appears to be by Nathan D. Taylor, based on style and the probable date of about 1920. (Courtesy of Darlene West.)

William Oscar Jones (1861–1931), one of the cotton buyers in Elberton, was a prominent banker and a business and civic leader who used his economic influence to improve business conditions for the whole city. One of his major businesses was the Elberton Cotton & Compress Company, considered the best of its kind between Atlanta and Norfolk in 1899, having compressed 18,000 bales in 1898. Because of his business acumen, Jones was the first president of the Elberton Chamber of Commerce formed in 1909 as the second commercial organization in the city. In bringing business to Elberton, he was legendary; and his role in persuading the Airline and Seaboard railroads to construct a new brick depot in 1910 is part of his legacy. He also was instrumental in bringing the Seaboard Silk Mill to Elberton. In addition to business interests, Jones also played other roles in the community, including membership on the Elberton school board. (Courtesy of *The Elberton Star & Examiner*.)

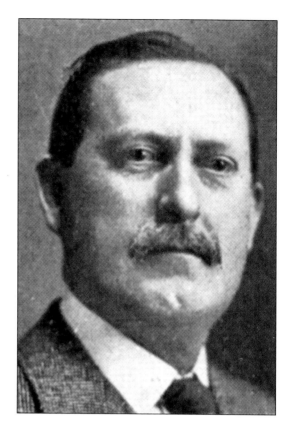

William Edgus Wallis (1870–1920), known familiarly as Gus, was a pioneer architect/builder who arrived in Elberton in the mid-1890s as a builder on the courthouse and remained in the city, where he designed many buildings, particularly a significant number for William O. Jones. (Courtesy of *The Elberton Star & Examiner*.)

41

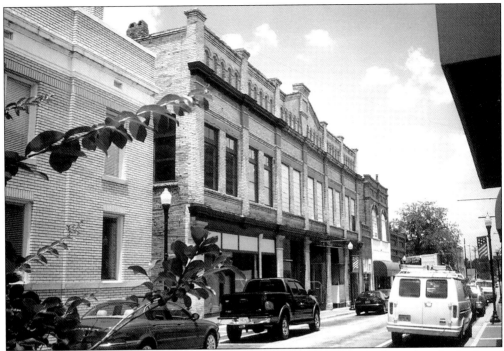

In 1904, after a destructive fire on North McIntosh Street, William O. Jones bought the lot of the burned-out Duncan Brothers store next to his lost building and assigned William E. Wallis to construct the new Jones Building of 1904 that combined three storefronts into one whole. A compelling feature of the new building was the specialized photography studio rented by J.H. Orr, who had lost all his equipment in the fire.

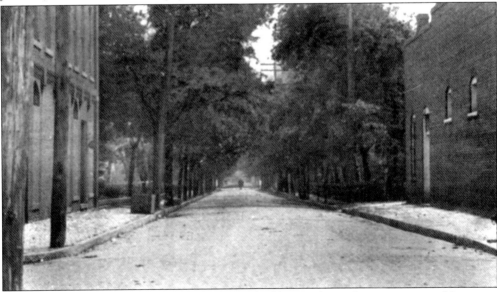

In 1907, William E. Wallis constructed a new brick building on the southeastern corner of the square and Heard Street to replace the historic pre–Civil War wooden store, where Gen. Robert Toombs was inducted into the Masonic rites. The Heard Street entrance to the building appears to the right side of this photograph. (Courtesy of *The Elberton Star & Examiner.*)

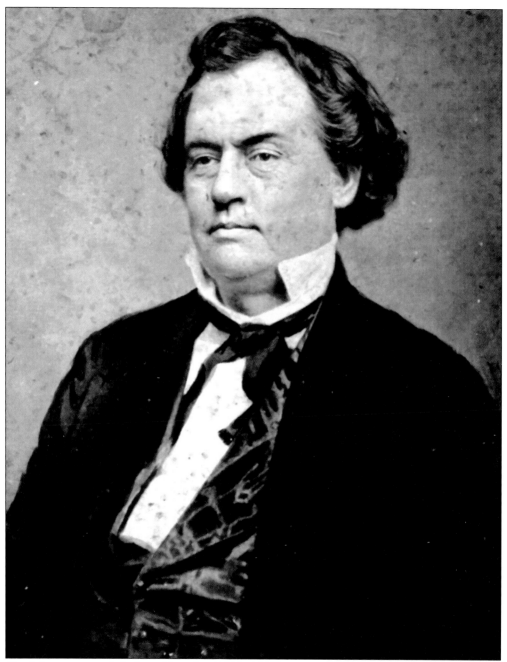

Confederate general Robert Toombs (1810–1885) was a resident of Wilkes County who passed the bar in Elbert County, where he practiced law extensively and earned much of his enormous wealth before the Civil War. In one single Elbert County court session alone, he earned $5,000. After the war, Toombs was one of the primary targets of his old foes and escaped from Washington, Georgia, to Elberton, where he took the Masonic rites in the lodge rooms above the old Jones store before escaping from the country rather than take the oath of the United States. (Courtesy of Hargrett Rare Book & Manuscript Library, University of Georgia Libraries.)

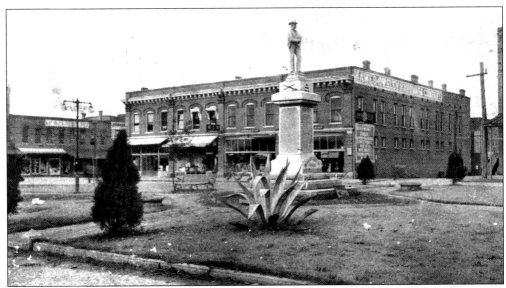

In 1906, Atlanta real estate magnate Thomas Day purchased a set of lots from the estate of the late John D. James and built the Day Block, a large storefront and office building, which was so popular that it was nearly filled with tenants when it opened in January 1907. William E. Wallis designed the building, which is visible across the public square. (Courtesy of Ted Dove.)

An example of William E. Wallis's use of decorative detail on the Day Block is the set of anthemion and egg-and-dart motifs on the capitals of the pilasters and the arch framing the windows.

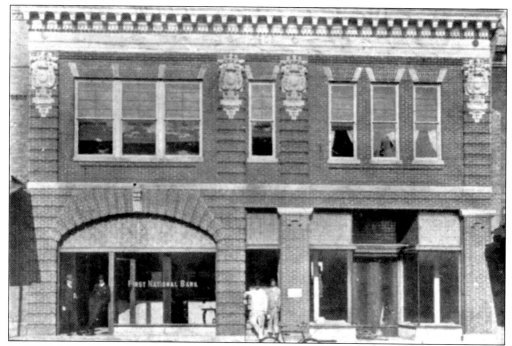

In 1908, M.E. Maxwell, J.R. Mattox, and J.L. Cauthen began the First National Bank with a capital of $60,000 and chose the old burned Brewer's Livery lot on Oliver Street for the location. With John N. Holder as president, the bank opened in fall 1908 in a new building that was especially dramatic and beautiful because of the ornamental cartouche (or decorative shield) motifs used between the windows on the second level. Inside the bank that occupied the western side of the street front, there were specialized features of a separate window for women and a special room for their use. These features of the bank were of such a functional nature that it is easy to accept the attribution of the design to William E. Wallis, who included similar functional elements in other buildings. (Courtesy of *The Elberton Star & Examiner*.)

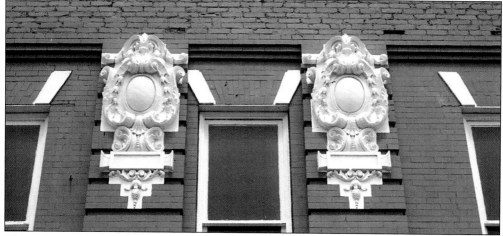

The ornamental cartouches adorning banded pilasters of the second story of the First National Bank building of 1908 are still in place today. Some ornamentation visible in the vintage photograph above is missing, however; today, one can only imagine the high level of attention this building received when it was new.

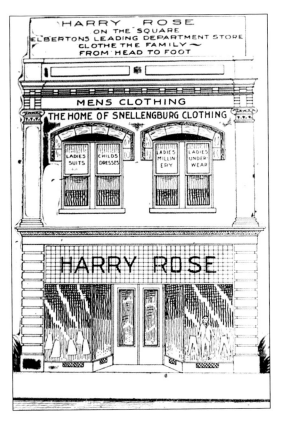

Harry Rose arrived in Elberton in September 1909 and began a brief but flamboyant career there as a merchant with a flair for advertising. Rose initially opened a store in the Brewer Building on the western side of North Oliver Street north of the First National Bank of 1908, although local merchants warned him he would not fare well there. Rose, however, stressed the value of publicity and followed his own advice by advertising extensively in newspapers in Elberton and surrounding counties. When the new Elberton Cotton & Compress Building was under construction in 1910, Harry Rose was one of its first tenants to rent space and promoted his new store with drawings made to project its final appearance. Although details in the printed drawing are somewhat different from the final forms of the building, Rose, nevertheless, conveyed his message of grand style and prominent publicity. (Courtesy of *The Elberton Star & Examiner*.)

In 1910, William E. Wallis designed and constructed the prestigious new Elberton Cotton & Compress Company storefront building on the eastern side of North Oliver Street. For this new beginning, Harry Rose purchased fixtures of Mission Oak manufactured specifically for his store by the National Show Case Company of Columbus, Georgia, and spared no expense in creating a grand-scale shopping experience for men and women. He devoted the second floor entirely to the comfort of women, who reached it by traveling on the first automatic elevator installed in Elberton. Rose provided special amenities for women, including baby-sitting services, magazines, and a place for lunch. Rose's brand of merchandising did not suit Elbertonians, apparently; after suffering some major losses, he soon left the scene as quickly as he had arrived. (Courtesy of *The Elberton Star & Examiner*.)

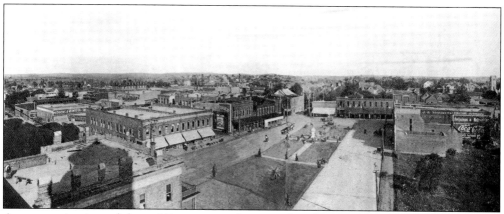

A panoramic view of the public square and surrounding business district of 1909 shows the new Day Block in the middle ground of the left side of the scene. The density of other business blocks around the popular Day Block demonstrates the high level of commercial growth and prosperity achieved in Elberton by the end of the first decade of the 20th century. (Courtesy of *The Elberton Star & Examiner*.)

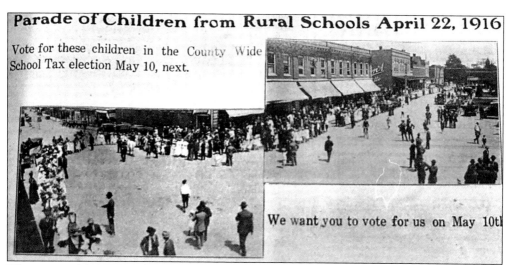

Elberton was like many other towns with growing pains. Its citizens and those of Elbert County contended often over such issues as taxation to pay for services and other civic responsibilities. One method of attracting attention to the issue of school taxation took place in 1916, when groups favoring taxation for educational funding promoted images of county school students, who had been transported to the public square for various other events, as propaganda for their cause. (Courtesy of *The Elberton Star & Examiner*.)

On December 23, 1919, a fire destroyed the western half of the Day Block, which the First National Bank had owned and occupied since 1917. The Strand Theatre next to the bank also burned, but the eastern half of the building owned by Dr. Charles F. Herndon that housed his Herndon Drug Company was saved by the firewall William E. Wallis had installed during construction in 1906–1907. In 1920, architect TenEyck Brown of Atlanta designed a new building for the First National Bank, which opened for business there in 1921. The stylistic disparity and difference in scale of the new bank and the remaining eastern half of the Day Block are notable in modern photographs, but both buildings are excellent and beautiful examples of their own periods. Dr. Charles F. Herndon, who had opened the Herndon Drug Store in the western half of the Day Block in 1907, in 1919 owned the eastern half, where he operated his drug store, which was spared from fiery destruction. He continued to operate his drug store in the remaining eastern half until he sold it to Dr. Fife of Lakeland, Florida, in 1946. The store operated as Herndon Drug Company until its closure in 1998 and today is part of the J.C. Pool Company, which expanded its facilities into the entire block of the old First National Bank building and the eastern half of the Day Block.

In July 1919, Bank of Elberton executives announced they would tear down their old bank of 1896. For temporary quarters, they acquired the old Citizens Bank building on the eastern side of the square. William E. Wallis once more designed a building for William O. Jones, president of the Bank of Elberton. The new Bank of Elberton opened in 1920, with joyous publicity and glowing descriptions of the beautiful interior, but the bank folded in 1926. The building was not out of use long, however, for in early 1928, the newly formed Granite City Bank opened in the same building. Closed in 1933 by order of the newly elected President Franklin D. Roosevelt, the bank reopened soon afterward as a State Depository and remained in business on the spot until construction of a new bank building on Heard Street in 1966. Wallis's Neoclassical building, which is in excellent condition and has had only minor alterations, is the present home of *The Elberton Star & Examiner.*

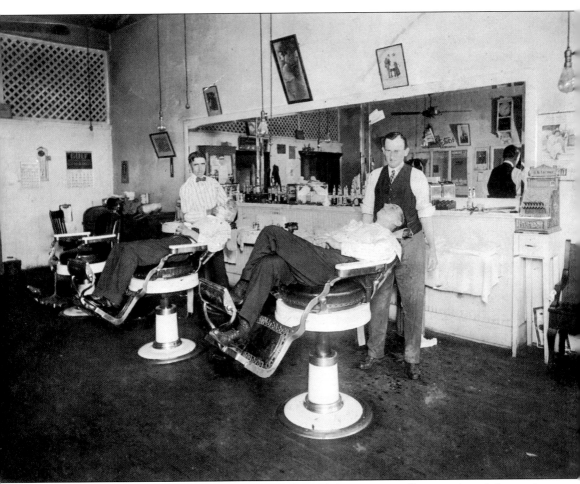

The Hudgens-McIntosh Building of 1906 housed businesses still remembered by native Elbertonians. The barbershop of James Rowland Farmer, shown at the left serving one of his customers, operated in the building from some point from 1906 to 1919, when the business was sold. (Courtesy of James C. Farmer.)

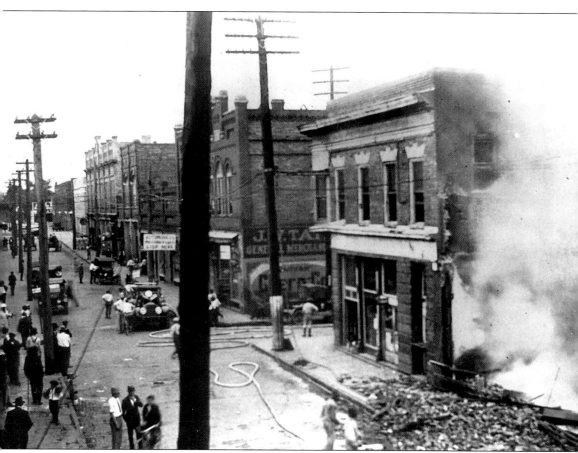

Many mercantile buildings burned in the early history of the city. Here, Elbertonians crowd into the streets for a post-disaster scene on North McIntosh Street in the 1920s. (Courtesy of the Elbert County Historical Society.)

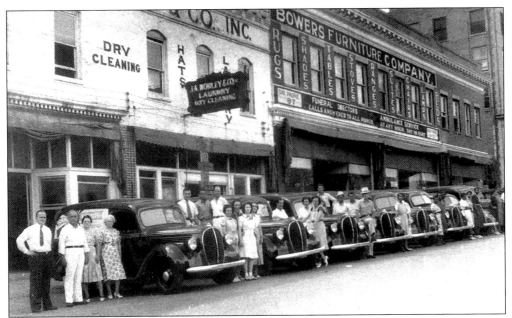

J.A. Worley & Co. operated in the Hudgens-McIntosh Building on the northeast corner of Oliver and Elbert Streets over 30 years. Above, from left to right, James Herman Worley and his father James Ambrose Worley pose alongside their employees and their new 1939 fleet of company cars. In 1958, when the city acquired and demolished business properties to build the Elbert Street Bypass, the property settlement covered only the building, not the business. George Worley noted in a recent interview that he returned to Elberton and closed the business in December 1958 for his father James H. Worley. (Courtesy of George Worley.)

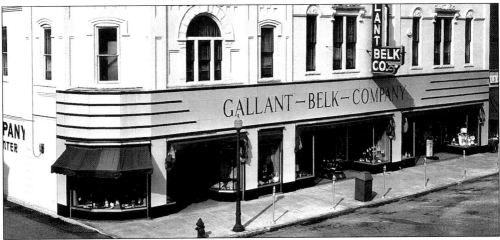

In 1929, the Gallant-Belk Company opened its first Georgia store in the reconfigured Almand and Wilcox storefronts of 1900 and operated in that arrangement until 1945, when the company leased the W.C. Smith building for additional sales space. A two-year renovation project resulted in the unified whole encased in a new Art Deco facade. The store closed in 1990 and, in 1997, young musician and entrepreneur Stan Brown purchased the Almand and Wilcox building complex, where he operates Stan's Music in the Wilcox building and rents the Almand building to the Love Unlimited bookshop. (Photograph by Everett W. Saggus, Courtesy of Shirley & Walter McNeely.)

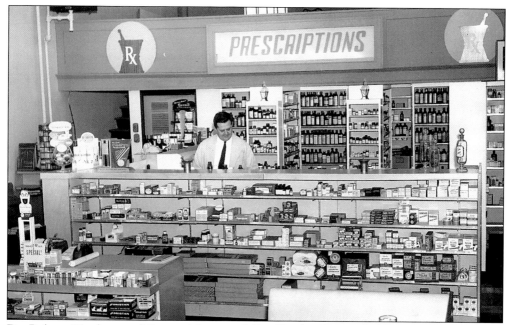

Dr. Robert Ward, son of Reese Adams and Dr. Charles P. Ward, fills prescriptions in his new drug store that opened December 1958 in the old building constructed in 1937 for Joe Allen and Dr. D.N. Thompson on the south side of the public square. In 2002, his son Dr. Robert Patrick Ward follows the tradition of his late father, filling prescriptions and serving the citizens of Elberton in the same spot. (Photograph by Everett W. Saggus, Courtesy of Shirley & Walter McNeely.)

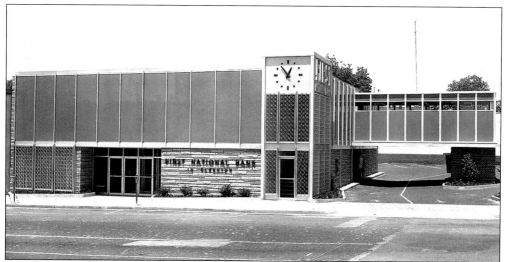

In 1959, James M. Hunt designed a new bank building for the First National Bank on the northwest corner of College Avenue and North Oliver Street. His design included a substantial amount of Elberton granite. The building served as the main bank for the First National Bank until 1992, when the newly renamed Pinnacle Bank constructed a new building on Elbert Street and converted Hunt's building into a branch. The building itself was later demolished and replaced by a new branch set west of the site to accommodate widening road construction. (Photograph by Everett W. Saggus, Courtesy of Shirley and Walter McNeely.)

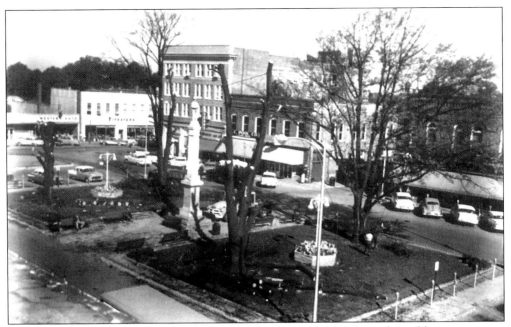

Changes occurring in the city by the early 1960s began to transform the public square once more. Benches set around the trees in the four quadrants had been moved to the center of the square by this time, and the trees were being cut because they were diseased. (Courtesy of *The Elberton Star & Examiner.*)

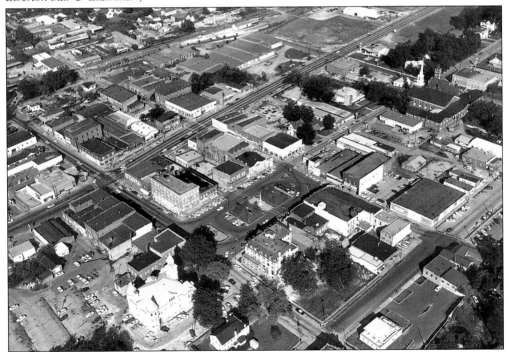

An aerial view of Elberton made by Everett W. Saggus in 1967 demonstrates how many of the buildings constructed in the mercantile district were demolished to make way for the Elbert Street Bypass. (Photograph by Everett W. Saggus, Courtesy of Shirley and Walter McNeely.)

Three

FORGING THE MANUFACTURING SECTOR

Elberton has had its share of major manufacturers of a variety of products, but the granite industry is the most enduring. Other mills have produced cottonseed items, cotton and cotton products, silk, clothes, and travel vehicles, while one franchise bottled the world-famous Coca-Cola. In the late 19th century, production began in the new granite industry that propelled Elberton into world markets. The discovery of strains of pure blue granite and the development of the industry by pioneers Dr. Nathaniel G. Long, W.M. Wilcox, Thomas M. Swift Sr., and others started slowly with a few quarries in Elbert County and expanded into nearby regions. Soon, the city could advertise itself as the Granite City of Georgia.

By the mid-20th century, efforts were underway to organize individual quarry and granite finishing plant owners into a unified organization. In 1951, B. Frank Coggins Sr. brought Reginald French, executive director of the Barre Granite Association of Barre, Vermont, to the granite industry in Elberton to lead the effort for organization of the companies. Later, a slight modification of the first organization led to the presently constituted Elberton Granite Association, Inc., which operates the Elberton Granite Museum & Exhibit consisting of photographs and detailed historical accounts of the development, growth, and worldwide expansion of the industry. A second major project of the association is a series of educational workshops.

Individual owners have made significant contributions to the development of the architectural framework in Elberton, and nearly every important building in the city contains some granite. In many cases, granite company owners have donated granite blocks and the released time of their artisans and practitioners to prepare and place granite blocks for monuments and complete decorative detail. The granite industry has dominated all others in the city for more than a half-century and provides employment to a large segment of the population of Elberton and Elbert County.

In addition to the granite industry, other manufacturing concerns have demonstrated significant achievements also. Early cotton mills and mills producing products from cotton and cottonseeds have played a part. In 1887, for example, Thomas M. Swift Sr. and his brothers began to explore the possibility of constructing a cotton factory to handle one of the most valuable crops produced in the South at the time and examined the available research before continuing with the venture in 1892. The Swift Cotton Mill, under Swift leadership and that of later owners, provided jobs to a large segment of the community for generations to come. The Elberton Oil Mills opened in the late 19th century as a

consortium of factories manufacturing soap and rope, as well as products from the cottonseed and, at one time, employed a large segment of the area population, closing only in the mid-20th century.

In other areas, the production of wagons, carriages, and necessary accessories became the focus of a number of several plants in the city. Fabric manufacturers also have played significant roles, but the most famous product produced in Elberton is Coca-Cola. In the late 1920s, H.J. Miller, along with his new co-owner of the Elberton franchise, built the first model bottling plant for the Atlanta company and set a standard for all other bottlers in the rest of the country.

Other unique manufacturing plants of the 20th century include the Seaboard Silk Mill, which was the only southern mill manufacturing silk from raw products sent from Japan and China. It was special because railroad officials worked closely with civic leaders of Elberton to bring it to the city, and the owners in turn honored the railroad and its officials by naming the mill after the railroad. The mill, however, ended its silk production when Japan declared war upon the United States by bombing Pearl Harbor on December 7, 1941. The mill opened later under a new name and produced products from raw materials available elsewhere and has operated under other ownership, producing a variety of products to the present time.

A second special manufacturing center is the Elberton Manufacturing Company, which James M. Hunt designed in 1955 as a modular unit, to which he would add sections as the needs of the plant developed. His modular design was characteristic of his modern and streamlined approach to 20th-century architecture. Numerous other mills and plants have opened and closed in Elberton for the production of a wide variety of products. The temperate climate and open spaces around the city have provided excellent opportunities for many manufacturers in Elberton.

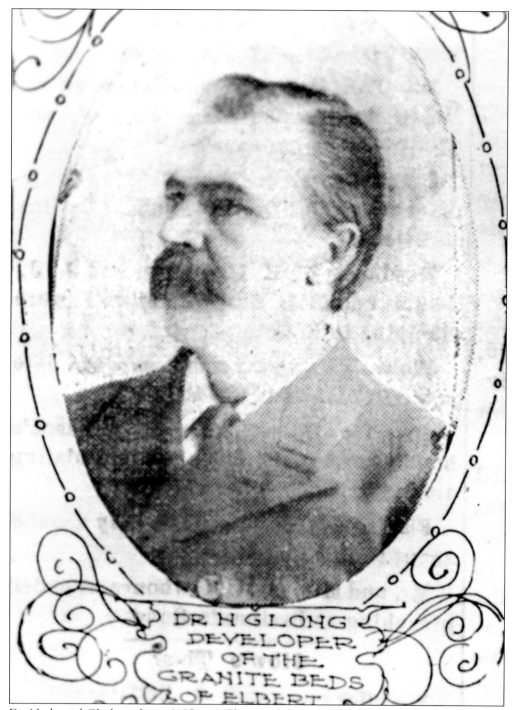

DR H G LONG
DEVELOPER
OF THE
GRANITE BEDS
OF ELBERT

Dr. Nathaniel Gholston Long (1854–1917), one of the granite industry pioneers in Elberton, was also a medical doctor, state senator, business entrepreneur, builder/architect, founder of the Elberton telephone system, and one of the early owners of *The Elberton Star*. In 1889, Long opened the first commercial quarry in Elbert County and consequently earned the title of "Developer of the Granite Beds of Elberton." (Courtesy of *The Elberton Star & Examiner*.)

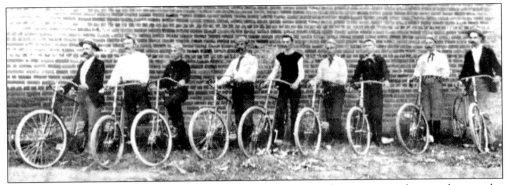

W.M. Wilcox, pictured on the far left, in a youthful adventure on the newly popular bicycle around 1895, was a second major developer of the granite industry. He also operated other major businesses, including stores and a real estate agency. (Courtesy of *The Elberton Star & Examiner*.)

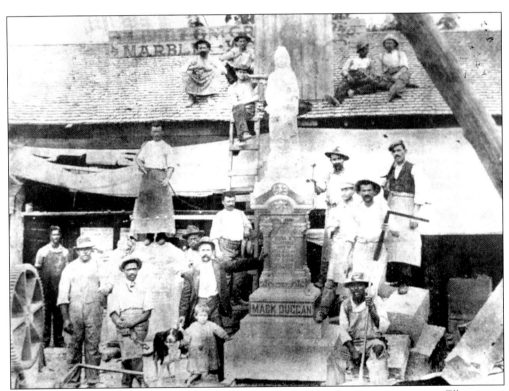

The Elberton Star reported in 1937 that Peter Bertoni was the first man to come to Elberton to invest in the granite business and operate a polishing stand. Here, unidentified operators at the Bertoni Granite and Marble Works pause in the carving of an elaborate monument. (Courtesy of *The Elberton Star & Examiner*.)

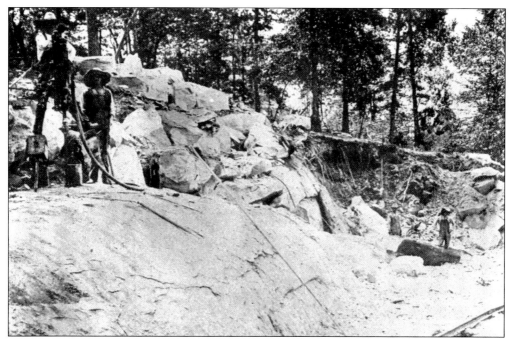

A 1909 scene of unidentified workers illustrates some of the granite beds from an unidentified quarry. (Courtesy of *The Elberton Star & Examiner*.)

A photograph of unidentified personnel in one of the granite fields from the early 20th century illustrates the extent of the growth of the granite industry in Elberton from its fledgling beginnings to the worldwide exposure it has today. In 1913, *The Elberton Star* advertised it as The Granite City of Georgia; today it is known as the granite capital of the world. (Courtesy of *The Elberton Star & Examiner*.)

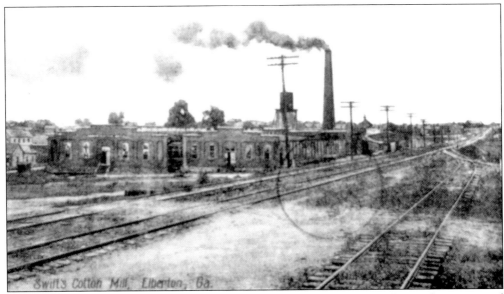

The Swift Cotton Mill opened in 1893 in Elberton. The 375' x 80' mill complex contained electric lights and its own water system, which was critical to the success of the mill in the years before the development of a successful waterworks system and a permanent fire department in the city. The Swift pump could produce as much as 750 gallons of water per minute and was part of the complex of two large holding tanks and a reservoir with a capacity of 85,000 to 100,000 gallons. An automatic sprinkler enabled Thomas M. Swift Sr. to obtain low insurance rates. After Swift ended his role in the mills, later owners operated it under other names well into the 20th century. Part of the old mill still stands and is used as the town's recycling plant. (Courtesy of Ted Dove.)

Samuel Hall (1855–1939), maternal great-grandfather of the author and son of a Confederate veteran, who worked in Thomas M. Swift Sr.'s Pearle Mill in the county, is shown at work in 1905.

The Elberton Oil Mills opened around 1890 and consisted of several factories, including one for soap and the oil seeds manufacturing operation. In 1907, the soap factory burned and was not replaced. Later, in 1963, after the mill had been idle for several years, the building burned just before its planned demolition. (Courtesy of *The Elberton Star & Examiner*.)

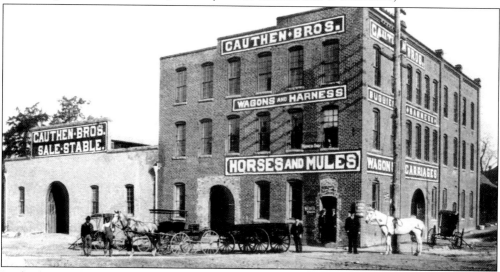

In the late 19th century, W.W. Adams and W.P. Clark built a buggy shop on the northwest corner of North Oliver Street and College Avenue and operated it until 1904, when they sold it to J.L. and R.A. Cauthen. The Cauthen Brothers, who had moved to Elberton from Hartwell, hired the Elberton Planing Company to completely remodel the building before moving the Cauthen Brothers horse and buggy business there. Improvements to the business included the construction of a brick stable building west of the main building for their horses. Here, unidentified individuals presumed to be the Cauthen brothers and their employees pose in front of the remodeled business establishment. Following the closure of the Cauthen Brothers Carriage and Buggy Shop, the Carhartt Factory used the building over a long period in the early 20th century. Later commercial properties were demolished in 1959, to make way for the new First National Bank. (Courtesy of Elbert County Historical Society.)

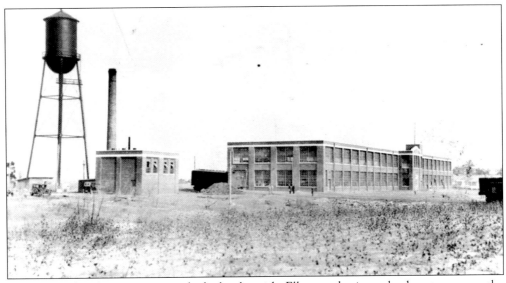

In 1926, railroad executives worked closely with Elberton business leaders to secure the Seaboard Silk Mills for the city. In the recent past, William O. Jones and other civic leaders had sought a new cotton mill but were delighted to acquire the only silk mill in the South instead. Chamber of Commerce officers and other civic leaders met often and long with railroad and mill officials to make the new mill possible and donated 35 acres on the northern side of Heard Street for its construction. It was the only mill of its kind in the South because it produced silk from raw materials imported from Japan and China. (Courtesy of Pat and Marvin Rathbone.)

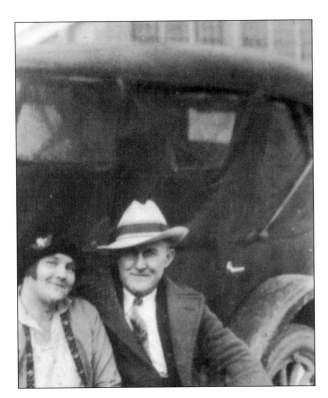

Seaboard Silk Mill owners constructed large cottages for their workers, including special homes for supervisors. Paul B. Rathbone moved to Elberton from Malorsville to assist in mill construction and remained to become one of the supervisors. He and his wife Jessie Davis Rathbone and son Marvin lived in the cottage closest to the mill, which is partly visible at the top of the photograph. (Courtesy Pat and Marvin Rathbone.)

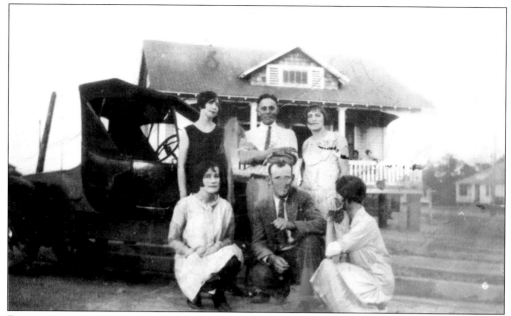

Former Fire Chief Niles Poole's family also worked at the Seaboard Silk Mill and lived on Cook Street in the mill village. In 1907, Poole's father Walter Eugene Poole (first row, middle) and his mother Ella Ruth Johnson Poole (first row, right) pose with his uncle Herbert Johnson (second row, middle) and some boarders at the house. (Courtesy of Niles Poole.)

When the Japanese Empire attacked the United States at Pearl Harbor in 1941, all commercial operations between the two countries ended. The Seaboard Silk Mill closed. Soon afterward, it reopened to produce other products and remained in operation until 1982. After a brief closure, it reopened once more as Glen Raven Inc.

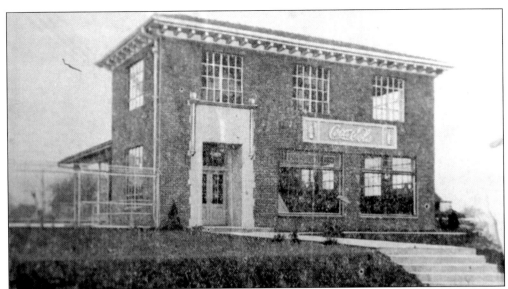

In 1928, H.J. Miller and C.C. Johnson built the first model Coca-Cola Bottling Plant according to the company's new set of standards for buildings, machines, and landscape. Francis P. Smith of Pringle and Smith of Atlanta designed the plant as an Italian villa, with classical and commercial motifs and decorations; it became the prototype for other bottling plants throughout the country. Local architect Hunter J. Price was the contractor for this significant example of product identification. Miller and Johnson brought in landscape architects to make the site beautiful and attractive to all visitors who saw it on the formal opening April 4, 1929. The building is now the home of the Agape Ministries. (Courtesy of *The Elberton Star & Examiner*.)

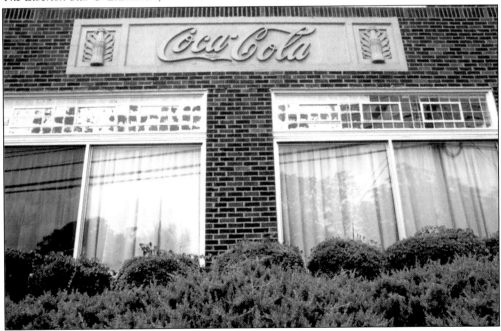

One of the decorative motifs Smith used on the top of the line Coca-Cola Bottling Plant in Elberton was the famous trademark name of Coca-Cola.

In 1951, B.F. Coggins Sr., was instrumental in the foundation of the Elberton Granite Association when he brought Reginald French from the Barre Granite Association of Barre, Vermont, to assist in organizing local granite companies. (Courtesy of B. Frank Coggins Jr.)

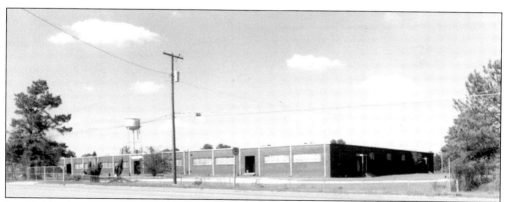

In 1955, the Elberton Development Company, consisting of Peyton S. Hawes Sr., Dr. Jack Wheeler, and James Cleveland, commissioned James M. Hunt to design a new manufacturing plant. Hunt planned a modular structure that could receive later additions without altering the original design. Their tenant was The Elberton Manufacturing Company, which opened in 1955 to make women's blouses. Additions to the original core of the building were made in 1957, 1958, and 1960.

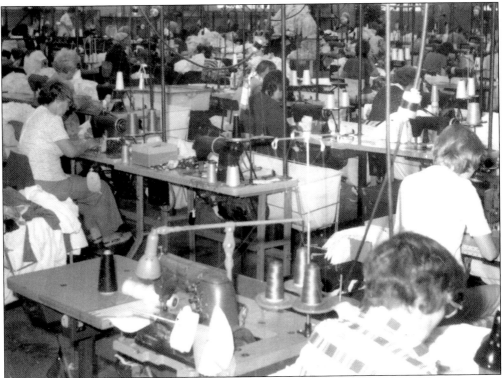

Operators in the sewing room of the Elberton Manufacturing Company work steadily in their efforts to "make production," that is, sew a required number of items in a determined period, and thereby earn middle-class wages at the plant that began operation in 1955. (Courtesy of Iris T. Anderson.)

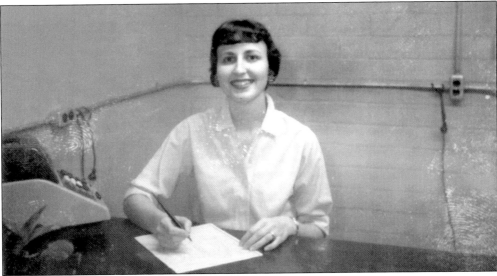

Iris T. Anderson entered employment at the Elberton Manufacturing Company in May 1955, when the plant opened, and worked there throughout a 41-year tenure as bookkeeper, office manager, and comptroller for bookkeeping operations of the company throughout the state. Here, she pauses in her duties to pose for the camera. (Courtesy of Iris T. Anderson.)

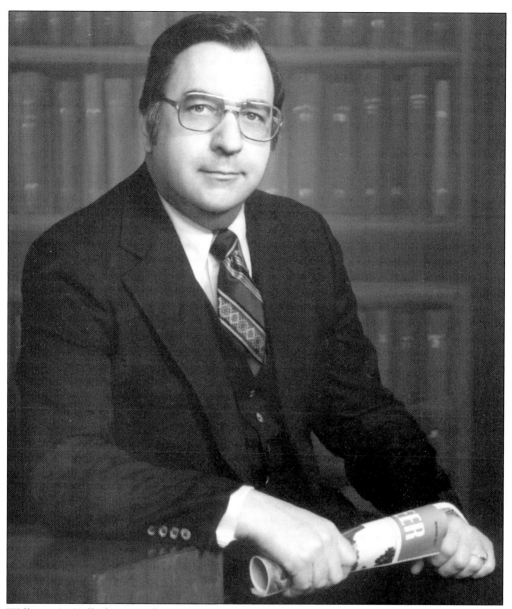

William A. Kelly became the executive vice president of the Elberton Granite Association, Inc., in 1955 and remained in this busy and influential post until his retirement in 1990. The granite industry achieved many mileposts during his tenure, including the construction of the Elberton Granite Association, Inc. headquarters building and the Elberton Granite Museum & Exhibit. He also initiated publication of *The Graniteer*, a valuable and informative trade publication for the granite industry. Additional contributions of Kelly during his long and influential tenure include the coordination of contributions by association members to the Bicentennial American Eagle Monument on the public square and other memorials. Kelly also instituted educational seminars on granite production that have become worldwide in their scope. His success as executive vice president of the Elberton Granite Association, Inc. led the Elbert County Chamber of Commerce to honor him with their second World Ambassador Award in 2002. (Courtesy of William A. Kelly.)

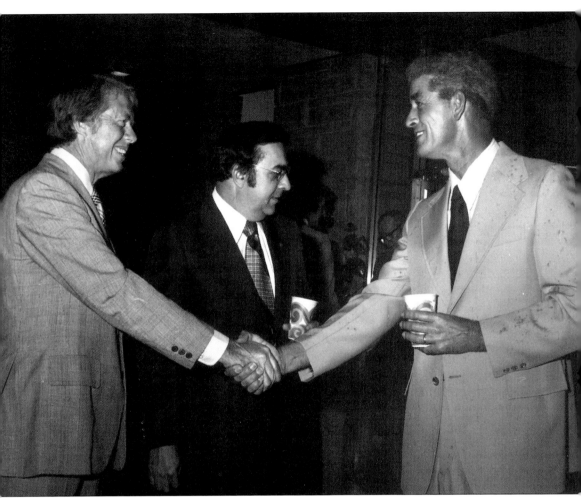

During his first campaign for the democratic nomination for the presidency, former Georgia governor and future United States President Jimmy Carter (left) visits with William A. Kelly, executive vice president of the Elberton Granite Association, Inc. (Center), and graniteer Tom Evans (right). (Photograph by Everett W. Saggus, Courtesy of Shirley and Walter McNeely.)

The Elberton Granite Association, Inc., headquarters building of 1961 is the product of a design competition for senior students in the School of Architecture at Georgia Institute of Technology. The building, which is clad in Elberton granite, is an example of modern 20th-century architecture.

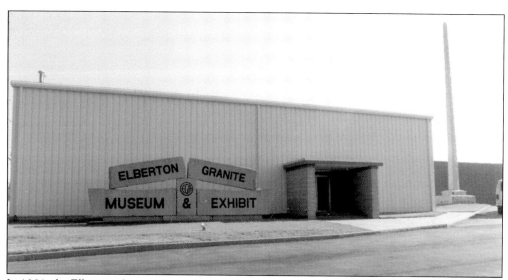

In 1981, the Elberton Granite Association, Inc., opened the Elberton Granite Museum & Exhibit to display valuable tools and artifacts of the industry. The museum is filled with photographs of the early history of the industry and models of special projects. Thomas A. Robinson, executive vice president of the Elberton Granite Association, Inc., and members of the staff provide valuable information to the many visitors the museum attracts.

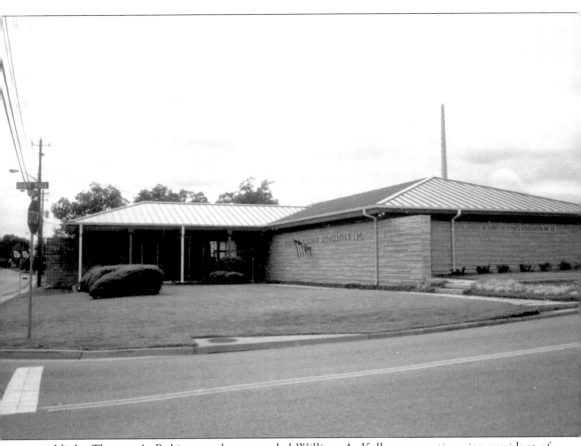

Under Thomas A. Robinson, who succeeded William A. Kelly as executive vice president of the Elberton Granite Association, Inc., a major project has been the addition of a high-pitched roof on the Granite Association headquarters in 2002.

Four

CONSTRUCTING A GRAND
RESIDENTIAL COMMUNITY

As the city of Elberton grew, many of its citizens began to enhance it with private residences that echoed the comparable growth of the civic and business sectors. Many of the early houses were large in size and scale and reflected personal wealth and large family size. Later houses were generally smaller and represented changing trends in lifestyles and architectural design, as well as changes in family size.

Many of the early palatial scaled houses are extant; in some cases, they are still in the hands of the original families. In others, the houses belong to new owners who prefer to live in historic houses. Some houses, however, are no longer in use for residences, for a number of new owners of these old homes have transformed them into business establishments. Inevitably, also, in a notable number of examples, some houses have been demolished for reasons ranging from the house's poor condition to the purchase of a house to demolish it and make way for construction of a commercial structure. Some houses have been moved to new sites also.

The surviving residential styles in Elberton include Greek Revival, Queen Anne in a variety of subtypes, Neoclassical, Colonial, and a wide range of 20th-century modern styles. Throughout its history, the city has been the site of major examples of American residential architectural styles.

Some houses of note from the 19th century were the John Adams Heard house on Heard Street that survived more than a century until its demolition in 1970, and the Willie Gaines house that survived a move from Elberton to Goldmine but burned a short time later. McAlpin Arnold's house equaled the Long-Waterman house in San Diego in grandeur and stylistic significance but burned shortly after his death. Surviving grand houses of the 19th century include the W.C. Smith house on Heard Street and the Willis B. Adams house on North Oliver Street. Both are in excellent condition and inhabited by young families interested in restoring and maintaining the historical settings.

In housing, as in all other architecture, the citizens of Elberton have followed trends typical of other small American towns in the use of common styles of all periods. The survival of houses of many styles adds to the richness of the city's architectural history.

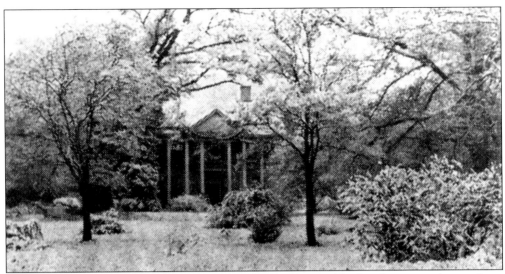

At some point in the early 19th century, John Adams Heard built a house on the southern side of Heard Street in the Greek Revival style. This scene shows the house covered by one of the few snowstorms Elberton experiences in its mild southern winters. The Heard house devolved upon family heirs and remained in the family until its poor condition made demolition inevitable in 1970. Judge Robert M. Heard spoke at length about this house and his family's extensive role in the history of Elberton during an interview in 1989. Judge Heard's distinguished record of civic service to Elberton includes the acquisition of the charter for the Elbert County Historical Society, which was created in 1976. A special accomplishment of Judge Heard was his publication of *Memories of Robert M. Heard, November 8, 1988*. (Courtesy of *The Elberton Star & Examiner*.)

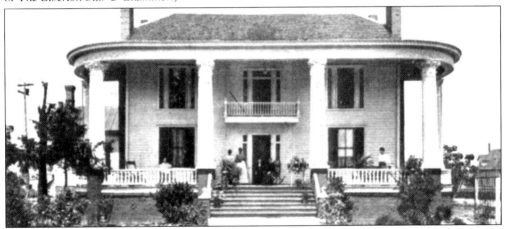

In the mid-19th century, Dr. and Mrs. Milton P. Deadwyler moved to Elberton from Danielsville, and purchased the house on Heard Street that became identified with the socially active and civic-minded couple from that point onward. After his death in 1895, Mrs. Deadwyler continued to entertain her friends in well-publicized dinners and to support projects of interest to both, including construction of the third First Baptist Church from 1897 to 1898. Despite the full social calendar at the Deadwyler house, the individuals posing on the elegant porch cannot be identified here. The Deadwyler house, which represented a southern variation on the Greek Revival style, was demolished in 1964 to make way for the new Granite City Bank of 1966. (Courtesy of *The Elberton Star & Examiner*.)

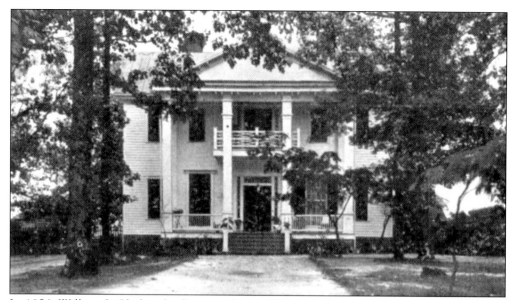

In 1856, William J. Clark, a leading merchant of Elberton, built a large Greek Revival house on Heard Street for his family before going to fight in the Civil War. Clark died in battle; Mrs. Clark, widowed earlier before their marriage, remarried once again. After her marriage to John D. James, she continued to live in the house. So did her daughter Belle James, who married Ben H. Kay, and lived there also, and lent it the later designation of the Kay house. (Courtesy of *The Elberton Star & Examiner*.)

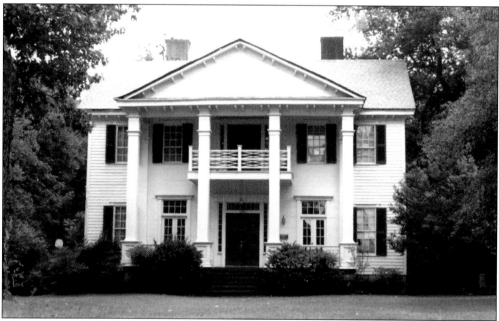

The William J. Clark/Ben H. Kay house is extant and nearly unchanged in 2002 in its external appearance from that in the above photograph of 1909. In 1904, it also was unaltered in appearance to Mrs. L.Y.A. Blackwell, when she described it and noted that it had not changed in the previous 40 years. Present owners of this historically significant house are Mr. and Mrs. John S. Jenkins.

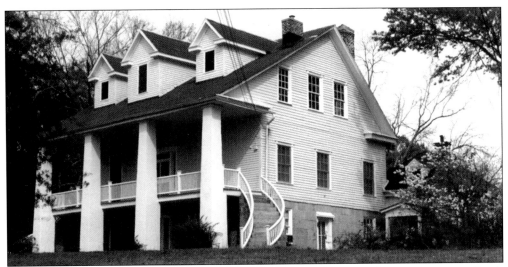

In 1852, William Augustin Swift (1806–1856) began construction of a new house on South McIntosh Street for his family, then residing in the upstairs apartment of the Swift store, but died in December 1856 after a buggy accident. Their grandson Chris Swift noted in the Elbert County Historical Society Cemetery Walk in 1996 that Mrs. Swift chose not to live there and sold the house, which became a boarding home for a time. Dr. A.S. Oliver, the only son of one of the wealthiest men in Elbert County, later purchased the house in 1879. Members of the Oliver family still own the house, which contains basement apartments and rooms upstairs for their use.

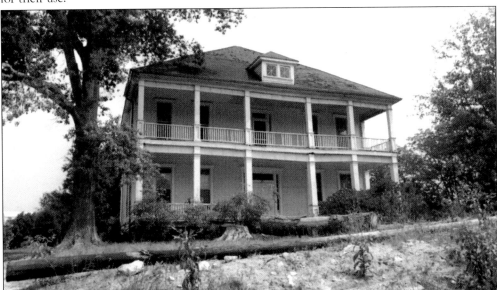

In the mid-19th century, Mr. and Mrs. William Henry Harper built the family house they shared with their five children on the northern side of College Avenue. Mrs. L.Y.A. Blackwell, reminiscing in 1904 about the previous 40 years, wrote in *The Elberton Star* that the house had been considered an excellent example of modern architecture in 1864. She spoke admiringly of the entire Harper family. A report mentioned by Irene Wilcox in *The Elberton Star* in 1979 that it was constructed around a log cabin core cannot be verified because the house burned in the last decade of the 20th century.

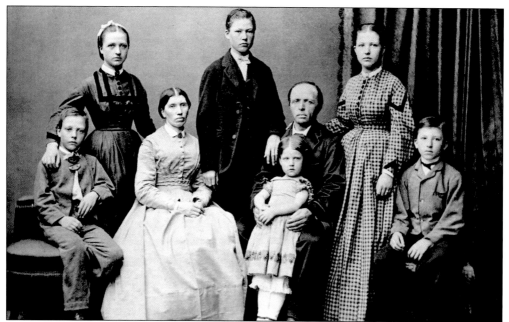

In October 1858, George and Henrietta Loehr, recent arrivals in Elberton from their native Germany, purchased a lot on present-day Heard Street, which was known then only as the road from the Elbert County Courthouse to Petersburg, where they built their new home. Herbert Wilcox, in *Georgia Scribe*, described the legend of how the Loehr family introduced to Georgia the German tradition of setting up a tree to celebrate the Christmas holiday. Mr. Loehr carved wooden toys to be set out under the tree, while others contributed to the decoration of the tree with colored paper ornaments. The final touches included setting candles on the branches and placing a wooden fence in front of the tree to protect the children from danger. Mr. and Mrs. Loehr are shown seated with their children, whose memories of the Christmas tree tradition were cited by Wilcox in his account. (Courtesy of Shirley and Walter McNeely.)

The Loehr family home on Heard Street, which became known as the Christmas Tree House because of their inauguration of the German Christmas Tree tradition in the state, is still extant and has served many functions, including a short period as the home of the Elbert County Historical Society.

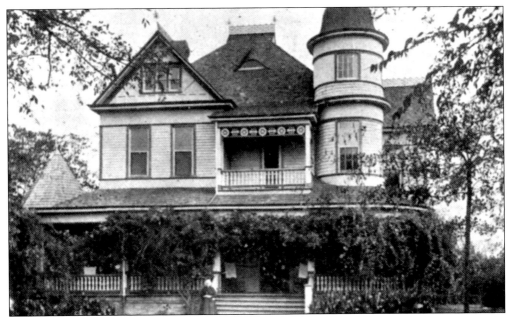

Three years after the death of McAlpin Arnold, his house on Heard Street, which was a premier example of the Queen Anne style, burned. His grandson and namesake Dr. McAlpin Arnold noted in a recent discussion that the family had purchased bricks in Savannah for a new house there, but sentiment for Elberton led to construction of a new brick house in Elberton, which was demolished later in the 20th century. (Courtesy of *The Elberton Star & Examiner*.)

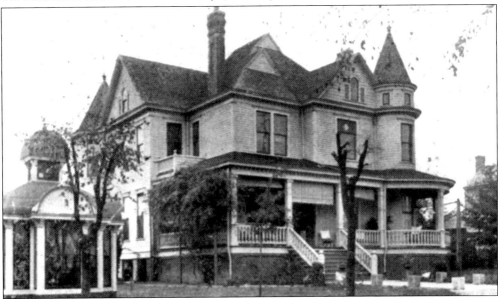

On the south side of Heard Street, Edmund Brewer Tate Jr. built what he called his Wheat House. He said that he earned the $5,500 cost of building it from speculating in wheat. Descriptions of the interior in 1904 listed electric lights that reflected upon the decorations set up in the beautiful dining hall. After the death of the second Mrs. Tate, the First Baptist Church bought the house and used it as the pastorium from 1934 to 1948. In 1952, the church demolished it to make way for new classrooms. (Courtesy of *The Elberton Star & Examiner*.)

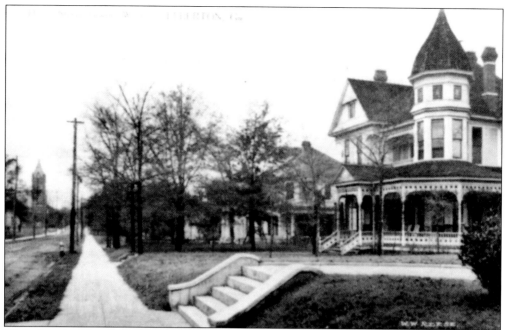

W.C. Smith was a prosperous merchant and active member of the Methodist church, whose large Queen Anne house on Heard Street symbolized his economic success in Elberton. (Courtesy of Ted Dove.)

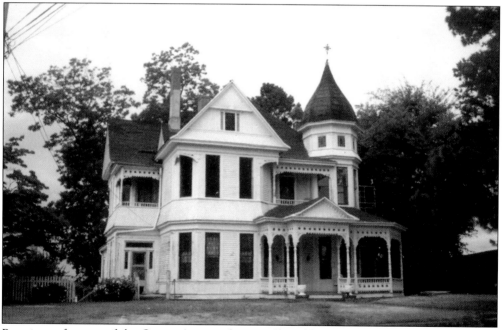

Prominent features of the Queen Anne style are still visible in the W.C. Smith house, which is extant but changed somewhat. After Smith's heirs sold the house in 1990, it went onto the market again; Nicole and Jeff Bartenfeld purchased it in 1999, to embark upon an ongoing restoration of this historic home.

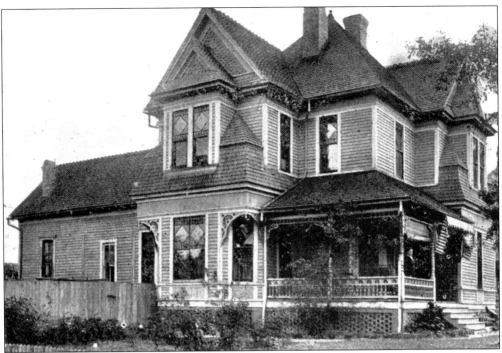

After L.L. Stephenson moved to Elberton in the mid-1890s to build the present courthouse, he remained in the city and built a family home on the eastern side of Tusten Street. Stephenson included numerous special features, including stained-glass windows in jewel-like colors. In 1904, S.S. Brewer, owner of mills, a livery stable, and extensive property holdings in the center of Elberton, bought the house from Stephenson. Present owners Joanne and Vic Gunter have restored much of the original decoration. (Courtesy of *The Elberton Star & Examiner*.)

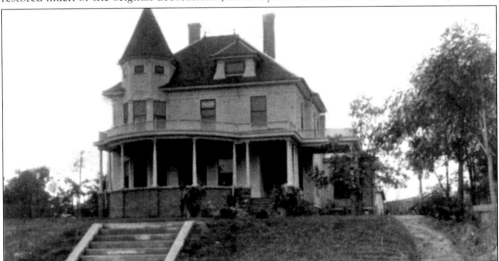

In 1904, J.A. Cauthen built a large family home on the southern side of Heard Street at the cost of $7,000. The palatial house was noted for a grand staircase and electric lighting throughout. In 1914, Cauthen created the ultimate barter by trading his house to Tom Pitts of Toccoa for 1,461 acres of land in Wayne County, Georgia. Later residents of the Cauthen house included the Herndon family. The house was demolished in 1975.

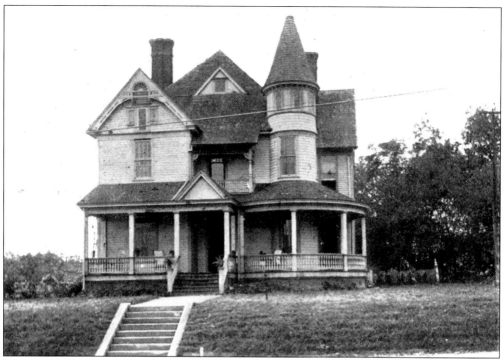

William T. Duncan, who appears on the cover as one of the cotton buyers, was one of many Elberton merchants who bought cotton on the square. His Queen Anne house on the southern side of Heard Street survived until the late 20th century, when it was removed from the site after serving miscellaneous uses, such as a haunted house for the Halloween holiday. (Courtesy of *The Elberton Star & Examiner*.)

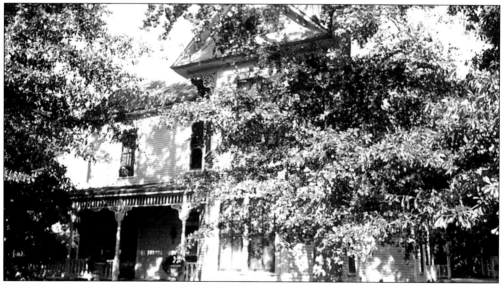

Willis B. Adams served the city of Elberton as mayor, chairman of the board of education, and Elbert County Representative in the Georgia House of Representatives. In 1891, he bought a lot on the eastern side of North Oliver Street and, soon afterward, built his Queen Anne house there. Adams's house is still extant, and its current owners are the Rick Higginbotham family.

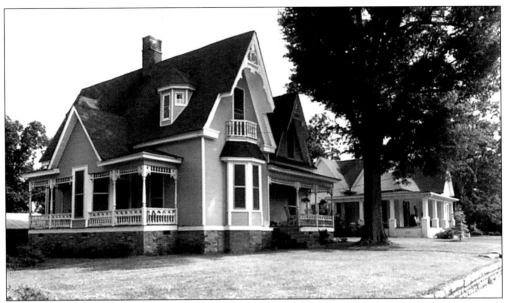

In 1879, E. Allen Cason, clerk of court later from 1917 to 1918, bought a lot on South McIntosh Street for construction of one of the most distinctive Queen Anne houses in the city. Noted for the C inscribed in its front roof gable, the house was easily recognized as the Cason home. Cason's granddaughter later willed the house to the First Methodist Church, from whom its present owners Pam and Larry Smith purchased it in 1975.

John Henry Jones (1816–1899), who served as justice of superior court from 1853 to 1857, was an important patriarch for the city of Elberton. He and his wife Lavonia Hammond Jones had many children, including prominent businessman and cotton buyer William O. Jones. John Henry Jones achieved success in life, but even more significant than symbols of his fame in Elberton was the international monument given by his daughter Lenora in his name to the Chinese people. In 1918, Ms. Jones dedicated the John Henry Jones Memorial Church in Lienze, China. James McIntosh noted in his *History of Elbert County Georgia 1790–1935* that the church serving 350 was still thriving at the time of his publication in 1935. (Courtesy of the Elbert County Library.)

In the late 19th century, John Henry Jones built a family home on the northern side of College Avenue that was notable for a wide variety of spindlework. (Courtesy of Ann and Harry Dunbrack.)

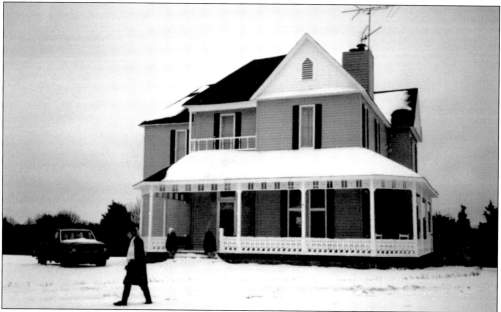

Long after the death of John Henry Jones and his family, the house had other owners but remained on the lot until 1979, when the city required it be moved or demolished because it had become an eyesore. At that point, Anne and Harry Dunbrack purchased the house and moved it to Christian Road in Bowman, Georgia, and made it their home after completing an extensive restoration. Their daughter Cindy D. Churney appears in the magical, snow-filled setting of the restored house. (Courtesy Ann and Harry Dunbrack.)

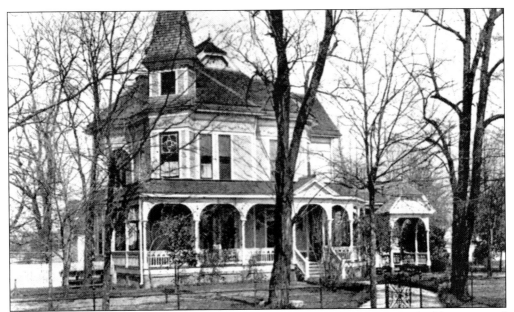

Isaac Glasgow Swift, youngest brother of Thomas M. Swift Sr., was a highly respected businessman in his own right. In 1888, he helped organize the Elberton Loan & Savings Bank as the first bank in Elberton and served as mayor of Elberton from 1883 to 1885. He married Bessie Thurmond, niece of Crawford W. Long, the discoverer of anesthesia. In 1895, the couple built a large new Italianate house on the northern side of Heard Street. At the cost of $9,000, it was one of the most expensive, but one of the most beautiful, houses in the city. (Courtesy of *The Elberton Star & Examiner*.)

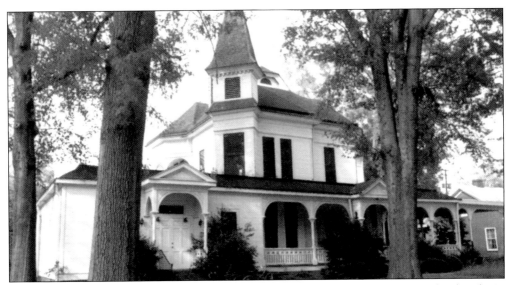

Later owners of the Isaac Glasgow Swift house included Mr. and Mrs. Z.W. Copeland and Mr. and Mrs. T.M. Martin, who converted it into the Martin Funeral Home. In 1992, its history was changed once more when Helena and Fritz van Richthofen purchased it and planned to restore it on the original site but later moved it to a new location in Greene County. Photographed before it was moved from the lot, the house is seen here in its stately setting on Heard Street.

J.M. Wester was a railroad official who served as mayor of Elberton from 1909 to 1914. Civic minded, he joined other merchants in entering a float in the big parade for the Granite City Carnival celebration in August 1899. In 1910, he opened the First Baptist Church Convention with a prayer on behalf of the city; in 1913, he welcomed the delegates to the Methodist Episcopal Church, South convention. The marriage was the second for Susie Rebecca Fortson and followed the death of her first husband. (Courtesy of *The Elberton Star & Examiner*.)

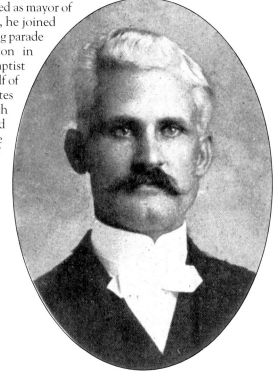

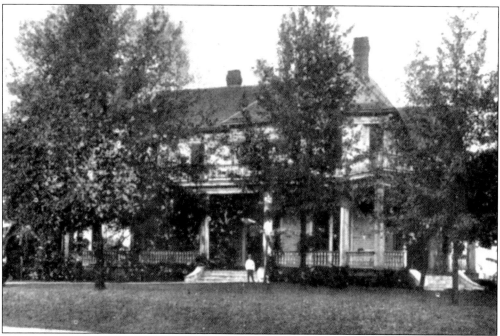

The Queen Anne–style Wester house was the first of the homes in the developed residential community of Heard Street to be destroyed. It burned in 1952 after the family had moved away from Elberton, and the loss initiated the erosion of the tightly unified residential unity of Heard Street. A car lot later replaced the Wester house. (Courtesy of *The Elberton Star & Examiner*.)

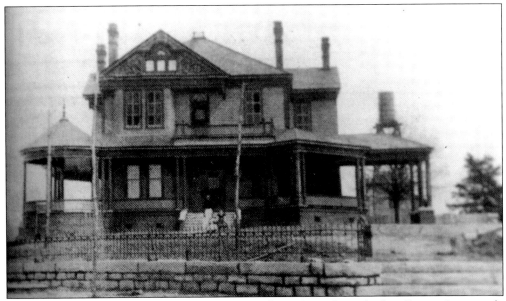

In 1893, merchant, banker, and cotton buyer William Oscar Jones built a Queen Anne–style house on a rise overlooking College Avenue, where he was able to move in immediately with Mollie Gardner Jones, whom he married that year. Unidentified individuals pose in front of the house. (Courtesy of *The Elberton Star & Examiner*.)

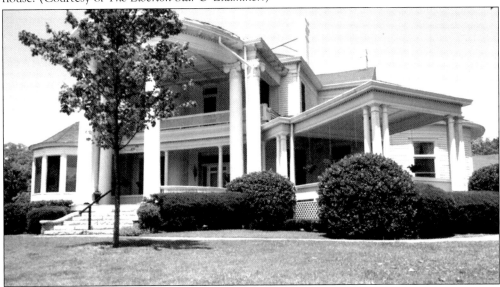

In 1905, William O. Jones commissioned William E. Wallis to transform his Victorian house into a neoclassical masterpiece by adding a large, curved portico and classical veneer to the Queen Anne core. Later, in 1983, Betty Anne Rampey purchased the house and reopened it as the elegant Magnolia Estates retirement home. Throughout the interior and exterior, Rampey has maintained the impact of the grand manor house on the hill, although the felling of many of the original magnolia trees and cutting away of a significant portion of the front lawn to make way for road construction has left the front yard looking somewhat truncated. This impact, however, is not visible up close to the house or from any other part of the property, which is one of the highest points in Elberton.

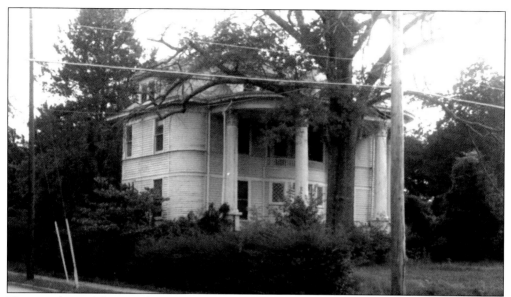

The neoclassical house of Mrs. Willie Carpenter Gaines, which was built in 1905 on the southern side of Heard Street, was special because of its beautiful curved front and its location on the southwest corner of Heard and Tusten Streets. The history of the house had a sad ending, however, because Cheryl and Steve Hanley purchased it and moved it to Goldmine, Georgia, in the mid-1980s. Then, a few years later, the house burned while they were away from home.

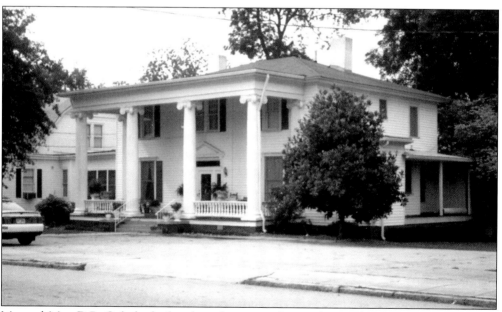

Mr. and Mrs. D.P. Oglesby built a large house on the northern side of Heard Street, where they brought up their six daughters and one son. Oglesby was a merchant and business leader who served on the city council in the 1880s under Mayor Isaac G. Swift. Their daughter Addie married S.O. Hawes, one of the cotton buyers featured on the cover. The house is a large and expansive one now being used by the present owners Joyce and Alvis Florence as the Rainbow Manor, a place for banquets, luncheons, and parties.

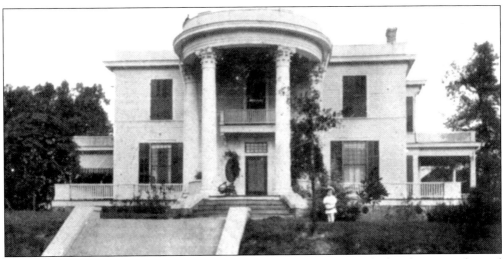

In 1907, R.E. Oglesby, another of Elberton's prominent merchants, built a large neoclassical house on the northern side of Heard Street that reflected the high level of economic prosperity in the mercantile sector of Elberton during the first decade of the 20th century. Oglesby went into business with W.T. Arnold and his sons in 1910 and later, in 1914, opened a store in the old C.J. Almand building on the south side of the square. In later years, the house had other owners. After serving briefly as the home of the Elbert County Chamber of Commerce, it was purchased by the McLanahan family and moved by Neal McLanahan to a new lot off the Calhoun Falls Highway, where his son Rod lives with his three children. (Courtesy of *The Elberton Star & Examiner.*)

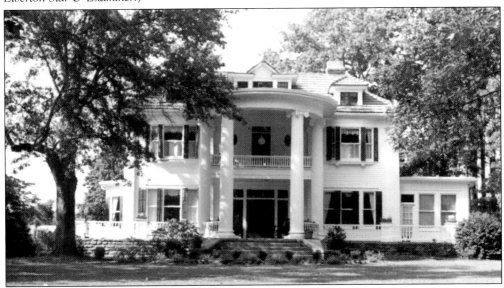

In 1909, William E. Wallis built a large neoclassical house on the northern side of Heard Street for Luther Martin Heard, husband of Mamie Latimer Heard and father of the Hon. Robert M. Heard and A. Latimer Heard. Heard's house, like Oglesby's was neoclassical, a very popular style in the early 20th century. Luther Martin Heard was a civic and business leader of Elberton who served as cashier of the Bank of Elberton and president of the Citizens Bank. In 2000, his grandson Latimer Heard and granddaughter Estelle Heard Zeiler restored the family house to perfection.

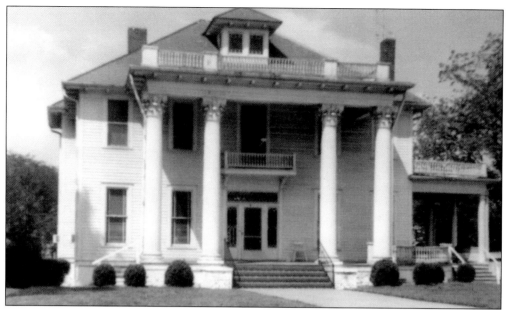

Joe Cohen moved to Elberton about 1890 and became one of the major merchants in the city, although he continued to maintain his contacts in New York, returning often to buy goods for his store. Notable for contributions to causes, including service on the local committee to raise funds for starving Jewish children of Eastern Europe after World War I, Cohen gradually added to his visible symbols of wealth. After living in his store in the early years and later in a rented small cottage, he moved first to a bigger house. In 1909, Cohen built a large neoclassical family house on the northern side of Heard Street on a lot he purchased from W.C. Smith. Mr. and Mrs. Cohen had three daughters, but none remained in Elberton. Thus, in later years, the house became the home of Elberton Department Store Funeral Home and Hicks Funeral Home successively.

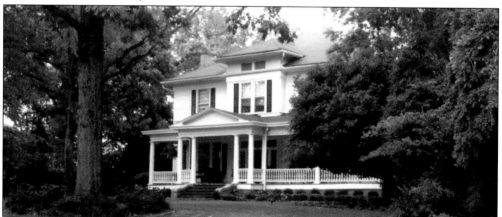

Dr. Albert S. Hawes moved to Elberton after practicing medicine in Atlanta. He also served both as member of the Georgia House of Representatives and mayor of Elberton. After living for a short while in the Maxwell House, in 1908 he and his wife commissioned William E. Wallis to design a Classic Box Palladian house on the northern side of Heard Street. The house was later the home of his son Peyton S. Hawes Sr. and family. The house is notable for its use for services of the Episcopalian Church in the early days of the establishment of the Episcopal congregation in Elberton, before construction of St. Alban's Episcopal Church.

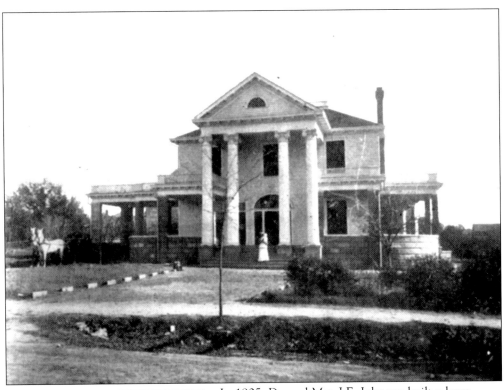

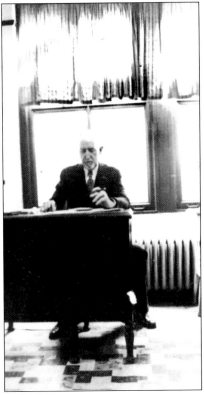

In 1905, Dr. and Mrs. J.E. Johnson built a large neoclassical house on the eastern side of Thomas Street, at the cost of $7,500. The house had a common backyard shared by Mrs. Johnson's parents, who lived in the old Heard house on Heard Street. Unidentified members of the family and staff pose for the photographer, while family horses wait patiently for their next outing. The house is almost unchanged on the exterior but has received some internal modifications to become law offices, initially for Heard and Leverett and now for Leverett and Daughtry. (Courtesy of *The Elberton Star & Examiner*.)

In September 1954 (before his death in November of that year), after having practiced medicine in Elbert County for nearly 50 years before retiring in 1944, Dr. J.E. Johnson quietly celebrated his 92nd birthday in reported good health. Dr. Johnson, who performed the first appendectomy in Elbert County, was an old fashioned doctor who traveled about the county in his two-horse buggy, leaving his home early in the morning, taking meals with his patients, before arriving home after dark. As soon as cars became available, however, Dr. Johnson purchased one of the first in the city, driving first a Maxwell and then a Firestone. (Courtesy of Peggy Johnson.)

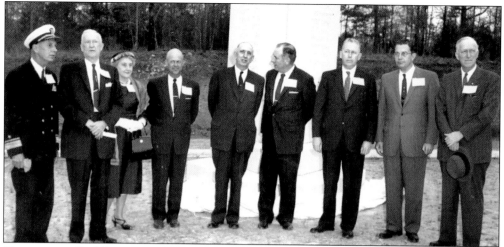

Congressman Paul Brown represented the 10th Congressional District of Georgia in the United States House of Representatives from 1933 to 1961. As vice chairman of the Banking and Currency Committee, he worked diligently for legislation establishing the Commodity Credit Corporation. His legislative efforts to assist farmers and all other constituents led to community tributes, including Paul Brown Day in Elberton in 1955. One of the poignant official events Brown attended, however, was the dedication in 1958 of Bobby Brown Park in honor of his son, who gave his life in military service during World War II. Dr. McAlpin H. Arnold, who had served as a page to Congressman Brown, officiated at the dedication of the memorial. The group included (from left to right) the Commandant Rear Admiral J.C. Daniel of the 6th Naval District, Congressman Brown, Mrs. Brown, Wilbur H. Hoover, Sen. Richard B. Russell, Gov. Marvin Griffin, Julius P. McLanahan, Lt. Gov. Ernest Vandiver, and Peyton S. Hawes Sr. (Photograph by Everett W. Saggus, Courtesy of Shirley and Walter McNeely.)

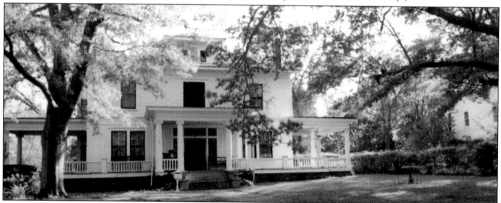

In 1920, before his election to the United States Congress, Paul Brown had purchased the house H.B. Swearingin built in 1910. Time spent in their house in Elberton was precious to the Brown family. Rosalyn Brown has fond memories of their time there and notes that they were always happy to return home from Washington. She describes many trips her father made around the district to meet constituents but said that he was always delighted to return to his home on Heard Street to relax on the porch, smoking a cigar. While Congress was in session, Congressman Brown, who was an avid baseball fan, attended games for a brief respite from his rigorous schedule. Congressman Brown's conscientiousness led him to meet nearly every roll call during his 28 years of service and to win honors from his peers for his voting record. The Brown house is now the home of Barbara and Wayne Gailey.

In 1952, James M. Hunt designed his own house, which he planned so that it follows the sloping lines of the wooded landscape that was an important artistic element in his total design. The house follows the incline of the hill in a series of tiers.

The tiers of James M. Hunt's house visible from the front entrance reflect the internal divisions of space set in the sloped lot, including a formal dining room Mrs. Hunt required for her professional needs as a home economist and for the entertainment needs of the Hunt architectural firm.

Five

ESTABLISHING
INSTITUTIONAL
FOUNDATIONS

In the two centuries since the foundation of Elberton, its citizens have established institutions of religious worship, educational training, medical services, and final rites.

Church history for Elberton follows the same path as mercantile and residential development. The spiritual need to worship in a public place led to the growth of churches, in concert with growth in other areas. In 200 years, congregations have built churches and proceeded to replace them with larger ones when they outgrew them or the old buildings deteriorated. Like other buildings in the city, churches have grown and developed according to individual congregational needs.

Schools in Elberton included male and female academies and later public schools, which merged students of both genders and then integrated schools by race. The story of education in Elberton continues with the construction of new schools at all levels. Libraries also have been important as centers of learning that reinforced the educational system of the city and county.

Hospitals and medical facilities appeared in Elberton at a slow pace first and primarily because of private fundraising projects. Some early facilities were in private homes donated to serve a need. Later, public facilities became possible because of governmental funding. Hospitals and medical facilities provide for health and welfare of the living, but the final story of many citizens of Elberton is told at Elmhurst Cemetery. This burial ground chartered in the late 19th century reveals a story of the famous and the non-famous Elbertonians of all eras.

Institutions, such as hospitals, schools, churches, and cemeteries, have followed the citizens of Elberton from the cradle to the grave and provide a framework for the stories of many of those who have lived in this historic city.

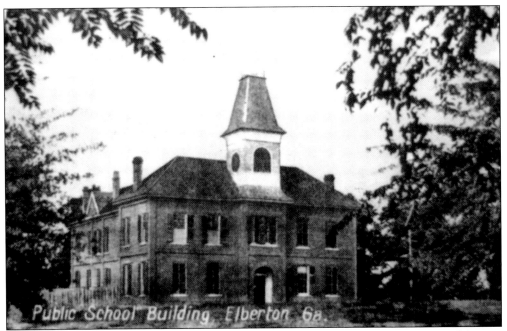

The Philomathea Academy, created by the Georgia Legislature in 1823 as one of four in Elbert County, was located on the southeast corner of College and Forest Avenues. Later names for the school included Elberton Male Academy, Male Institute, and The College. This brick school constructed around 1887 was a replacement for an earlier building but became inappropriate for the educational needs of the city after the school system became public in 1901. (Courtesy of Ted Dove.)

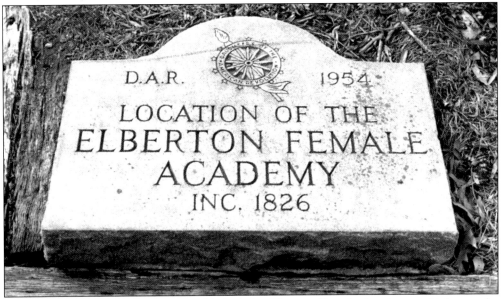

In 1826, the Georgia Legislature established the Elberton Female Academy, which was the second-oldest female school incorporated in Georgia, after the academy in Commerce. The building was adjacent to the site of the First Presbyterian Church on South McIntosh Street. It is no longer extant, but is marked by a DAR monument.

The Methodist church congregation in Elberton was created in October 1815 as the first established church in the city. Their third church is the present one built on the southwest corner of Church and Thomas Streets, because of consensus of a prayer group in 1886. Homer C. Mickel, parishioner and builder/contractor, designed the church, for which Luther Turner supplied the bricks from his kiln at Falling Creek. The new church was complete for service in 1889.

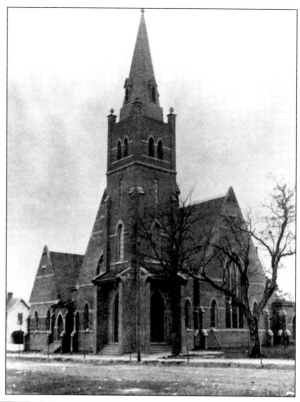

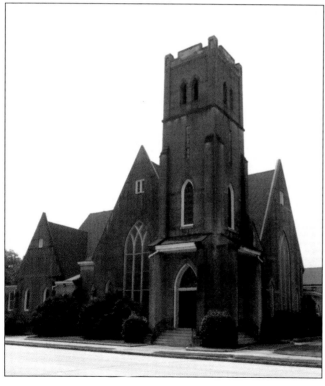

Storm damage led to the repair and remodeling in 1908–1909 of the Methodist Church by William E. Wallis, like Homer C. Mickel, a member of the congregation. Wallis added stucco to the original brick surface and created the effect of a rough stone surface but did not replace the steeple. In 1939, the Methodist Episcopal Church became the Methodist Church, and in 1968, the name was changed to First United Methodist Church. The bells heard every day at noon were added in 1946.

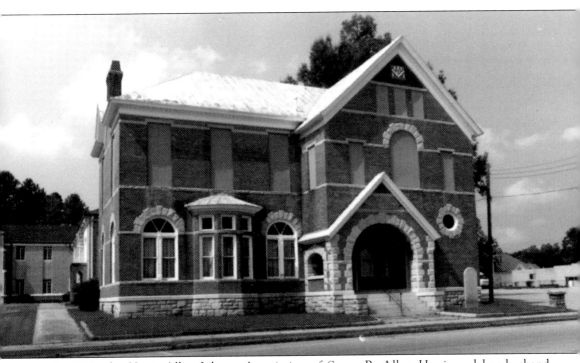

In 1891, the Harris-Allen Library Association of Susan B. Allen Harris and her husband Col. Young L.G. Harris of Athens joined the Philomathen Masonic Lodge #25, the Oliver Masonic Lodge #25, and the Free Masons in construction of the Harris-Allen Library & Masonic Lodge on Church Street. A heavy rain nearly ruined the elaborate cornerstone ceremony on July 29, 1891, but officials of Gairdner, Arnold & Co. lent their warehouse for the event. In their formal ceremony, Masons placed newspapers, bank papers, and a *History of Masonry in Elbert County* in the cornerstone. The library was later owned by the city, and Pauline Brewer Brown operated a small city and county library there from 1925 to the year of her retirement in 1960. The library remained there until the new county library replaced it in 1969. After the Masons built a new lodge on Industrial Boulevard in 1995, Interior Designer Susan Puleo purchased the Harris-Allen & Masonic Lodge building.

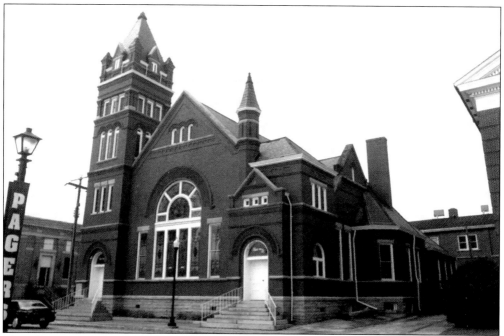

The Elberton First Baptist Church was established in 1860 and had two earlier buildings before the third of their four sanctuaries was constructed in 1897–1898. Reuben H. Hunt designed their new building, and Mrs. Milton P. Deadwyler continued plans she and her recently deceased husband had discussed at length with the Rev. H.W. Williams, who guided much of the planning for the new church. Mrs. Deadwyler also contributed significantly more than half the total costs of construction and furnishings of the church.

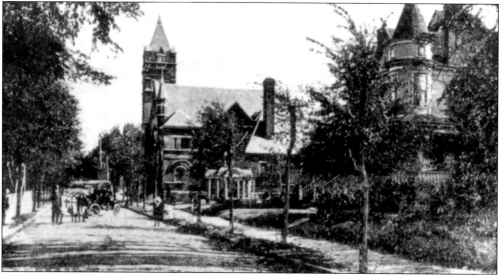

The new First Baptist Church (at the center of the middle ground) became an integral element in the large residential community on the upper part of Heard Street, where a number of unidentified individuals converge on one of many special occasions. One of these was the large Georgia Baptist Convention held in Elberton in 1910. (Courtesy of *The Elberton Star & Examiner.*)

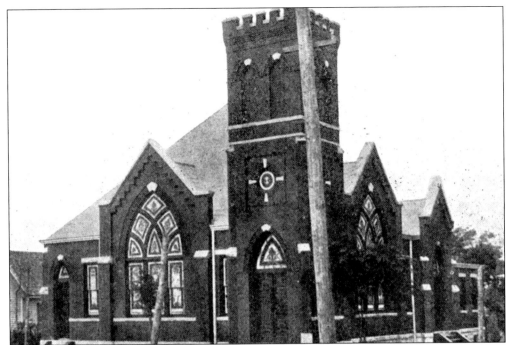

The Elberton Presbyterian congregation was organized October 15, 1865, as the First Presbyterian Church. After organizational meetings in the Methodist Episcopal Church, in 1878 they built a wooden church on South McIntosh Street, which they replaced in 1904–1909. William E. Wallis designed their new brick church from a design by Reuben H. Hunt. Service began June 1909, and the formal dedication was held four years later. (Courtesy of *The Elberton Star & Examiner*.)

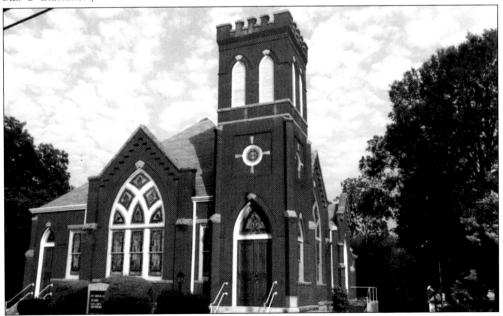

A modern view of the vintage First Presbyterian church reveals how little it has changed since its completion in 1909.

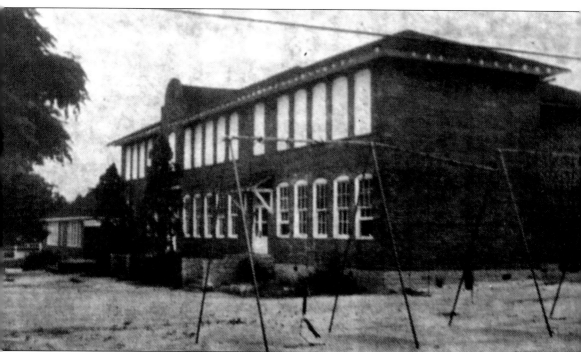

Blackwell School on Mill Street was built around 1909–1911 for African-American students before the racial integration of schools in Elberton. By the 1960s, the condition of the building had deteriorated so severely that school officials closed and boarded the second floor during its last five years of usage and planned to demolish it after completion of a new Blackwell Elementary School on Campbell Street. Following the opening of the new school in January 1970, the old building burned in February 1970 before its planned demolition in the following summer. (Courtesy of *The Elbert County Star & Examiner*.)

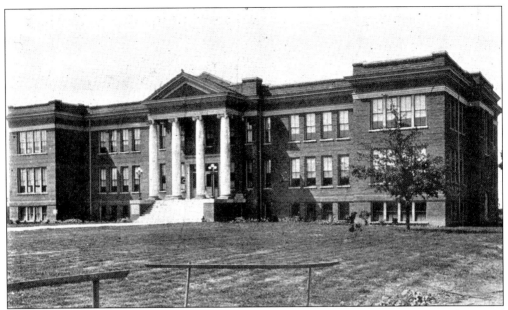

From 1909 to 1910, the city constructed a new Central School for white students on the site of the old Philomathea Academy building. J.E. Leiter, a native Georgian living in Wilmington, North Carolina, won the commission to design the new school, although school officials provided a significant amount of specificity for him. Despite strict control, Leiter succeeded in designing a school that was light and airy, but also beautiful. The resulting large school, built at the cost of $35,000, was a model of beauty and efficiency when it opened for white students in grades 1 to 11, in February 1910. (Courtesy of *The Elberton Star & Examiner*.)

Mattie Mary Fortson (1905–2001, later Mrs. Cecil Oglesby), far right on the second row, was among the graduates of the 1922 graduation class from the Central School, which was the largest graduating class of the school up to that point. In 1959, *The Elberton Star* published the image, which includes from left to right the following: (front row) Pauline Webb, Frances Thornton, Annie May Edwards, Arnoldina Thornton, Geneva Vest, Frances Moore, Velma Crawford, Sallie Mae Brown, and Nannie Lee Fulton; (back row) Nell Grimes, Nita Smith, Mary Brown, Young Smith, Mamie Jones, John G. Jones, Mildred Pitts, John Champion, Alice Nock, Arthur Wilhite, Nell Ginn, Etsel Snowden, Helen Brown, Peyton Hawes, Annel Higginbotham, Joe E. Johnson, Mattie Lee Cauthen, Rebecca Auld, Katrina Worley, and Mattie Mary Fortson. (Courtesy of Mary Thomas Thomason and *The Elberton Star & Examiner*.)

In 1945, the Elberton Hospital Authority, consisting of Chairman J.J. McLanahan, P.C. Maxwell, Frank Fortson, Z.W. Copeland, G.T. Christian, Glenn McGarity, and Tom Coggins, planned a new and permanent hospital on a site donated by Mrs. William O. Jones on Chestnut Street. The site was close enough to the city for convenience but far enough away to prevent the spread of germs, a concern expressed often when locations closer to the square had been offered in the past. In October 1945, William J.J. Chase of Atlanta, an architectural specialist in hospitals, designed a modern and spacious 50-bed hospital. Although it took five more years to complete, the hospital seemed on the way when Chase's design was published in *The Elberton Star* in December 1945. (Courtesy of *The Elberton Star & Examiner*.)

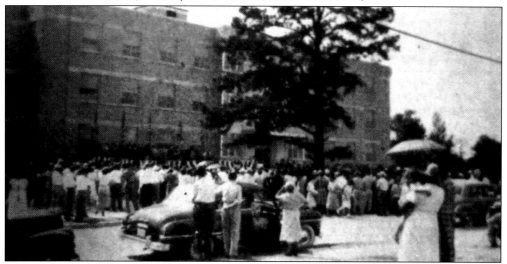

A large portion of funding for the new Elbert County Hospital resulted from passage of the Hill-Burton Act, which provided money for hospitals in rural areas. After Gov. Herman Talmadge signed the bill, Elberton received construction approval for its new hospital and became one of the first cities to take advantage of the law. On opening day in September 1950, Gov. Herman Talmadge delivered the dedication speech to a large crowd. (Courtesy of *The Elberton Star & Examiner*.)

Stewards and stewardesses representing individual church departments of the St. Mary's C.M.E. Church pause during a mid-1950s planning session for their church on Elbert Street. The Elberton congregation of the African-American branch of the Methodist Church, South, which had seceded in 1868, began as Salem Church congregation. In 1954, the African American Methodist Church in Memphis, Tennessee, officially adopted the name St. Mary's Christian Methodist Church, changing it from the old St. Mary's Colored Methodist Episcopal Church. The stewards and stewardesses depicted here planning cultural and social events for youth and adults include, from left to right, the following: (front row) Ms. Dennis, unidentified, Miriam Key, Mrs. Albert T. Smith Sr., Arlene White, S.M. Plummer, Ms. Key, Sarah J. Willingham, J.W. Willingham, Mamie Norman, T.R. Tharps, unidentified, and Walter Carter; (back row) Mr. Patterson, Charlie Tate, and unidentified. (Photograph by Albert T. Smith Sr., Courtesy of Albert T. Smith Sr.)

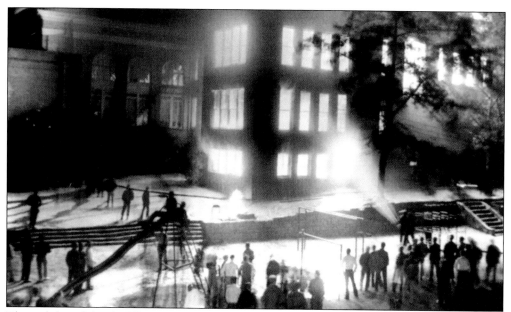

The solid, red brick Elberton Central School included many granite decorative features, but the building that seemed indestructible in 1909 burned so completely on the night of November 7, 1955, that it was beyond repair. Fragments still standing on November 8 revealed the seriousness of the damage to the school that earlier had suffered a small internal fire in 1954. Students spent the next two and a half academic years in makeshift classrooms in the First Baptist and First Methodist Churches. (Courtesy of *The Elberton Star & Examiner*.)

The Central School Graduating Class of spring 1955 was the last to pose for the traditional image of students walking into the building for end papers of the *Eidolon* yearbook. The last graduating class thus culminated a half-century old era of the Central School. (Photograph by Everett W. Saggus, Collection of the Author.)

The burned Central School was rebuilt in the modern style and opened in 1958 after students spent two and a half years attending classes in the First Baptist and First Methodist churches. Construction of the new Elbert County High School followed contentious dissent over the consolidation of the city school system with those of the county. The courts of Georgia ruled in favor of consolidation, and the new Elbert County High School opened in fall 1958 for white students in the entire county. Landmark years for the school were 1970, the year of racial integration of the Elbert County schools, and 1976, the year of the conversion of this school to the Elbert County Middle School. The middle school is seen here in a bird's-eye view from the upper porch of the William O. Jones house, now the Magnolia Estates.

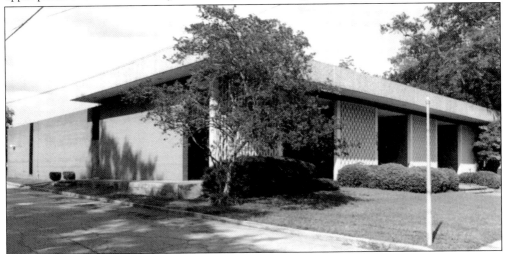

In 1967, the B.F. Coggins Foundation donated the site of the Early Thornton house on Heard Street to the county for construction of a new county library. James M. Hunt designed the new library, which opened in 1969 and continues to serve the city and county in 2002.

In 1965, St. Mary's Christian Methodist Church built a new sanctuary on Locklin Street and moved there from their old building on Elbert Street, which had to be moved to make way for the widening of the street when the city created the Elbert Street Bypass.

Albert T. Smith Sr., a designer and teacher in the Elbert County School system for 40 years, was the architect for the new St. Mary's Christian Methodist Church on Locklin Street. (Courtesy of Albert T. Smith Sr.)

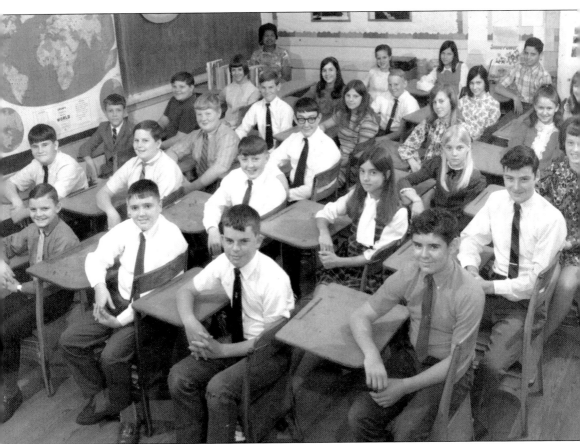

During the 1969–1970 academic year, Mrs. Albert T. Smith Sr. (Lorraine Smith) was among a small number of African-American teachers who entered formerly white-only schools in Elbert County to introduce the concept of racial integration to the county school system before integrating the student body. Mrs. Smith appears here, at her desk in the back, with her seventh-grade class at Stevens Elementary School. (Courtesy of Albert T. Smith Sr.)

In 1976, James M. Hunt designed a new Elbert County Comprehensive High School on Jones Street. The new school consists of four wings identified by colors flanking a central atrium that encloses the office, dining facility, and library. The old Elbert County High School became the Elbert County Middle School at that time.

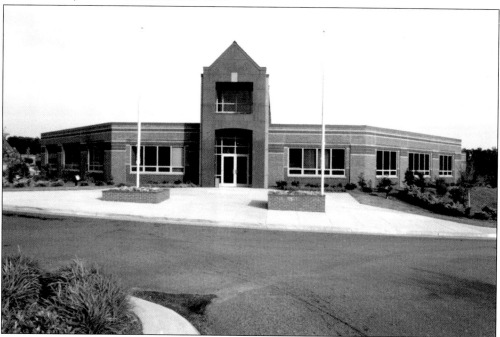

In 1997, on land donated by business leader B. Frank Coggins Jr., the Elberton Campus of Athens Area Technical Institute (now Athens Technical College) opened for classes. The Charles W. Yeargin Administration Building dominates its setting with numerous large windows providing a well-lit setting for administrative work and student needs.

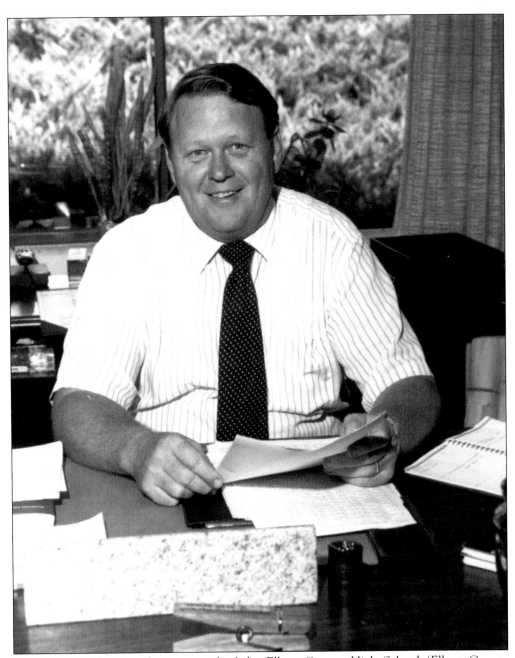

J. Paul Abernathy served as principal of the Elbert County High School (Elbert County Comprehensive High School from 1976) from 1972 to 1987. In 1984, when the Southern Association of Secondary Schools (SACS) accrediting agency rescinded its earlier easement allowing the new school on Jones Street to retain its accreditation even though its gymnasium was located at the old high school on College Avenue. Abernathy sought successfully to have the accreditation reinstated by promoting the construction of a new gymnasium, which was completed in 1986. For his service to the educational system of Elberton, Abernathy was honored when the school system named the entrance to the school Abernathy Drive. (Courtesy of J. Paul Abernathy.)

Charles W. Yeargin (1927–1995), who served 12 years as representative of the 90th District in the Georgia House of Representatives, believed in technical education and worked indefatigably for the installation of the branch campus of Athens Area Technical Institution (now Athens Technical College) in Elberton. Representative Yeargin appeared at the groundbreaking ceremony in 1995. The opening ceremony of the institution in 1997 was a sad time, however, for those who had worked with Yeargin, who did not live to see his dream of the Elberton Campus of Athens Tech completed. In 1996, the annual Charles W. Yeargin Scholarship was established in his memory for full-time students from Elbert, Wilkes, and Madison Counties matriculating at the Elberton Campus or at the Athens Campus if the recipient chose a field of study not available in Elberton. (Courtesy of Mrs. Charles W. Yeargin.)

A vital part of the community history of Elberton centers on the Elmhurst Cemetery, an institution, like many others, with close links to the Civil War. On March 11, 1883, a group of 59 citizens received a charter as the Elbert County Cemetery Association to sell lots in a 10-acre plot north of the city on North Oliver Street. Although designated as a privately owned public burial ground with no specific reference to interment of Civil War casualties in the charter, *The Elberton Star* noted that the cemetery was the ground for the reburial of Confederate soldiers. There was, however, a separate section designated for the burial of Civil War veterans, although many were buried in their own family plots. Herbert Wilcox wrote in *The Elberton Star* in 1962 that the name Elmhurst evolved over a period of time because of some elm trees in the area.

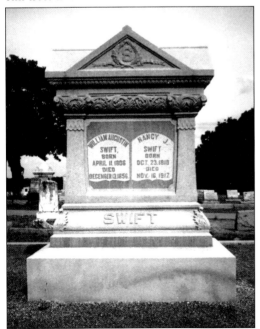

The oldest graves in Elmhurst Cemetery are closest to the prominent granite entrance gate on North Oliver Street, which was donated to the cemetery by the Elberton Granite Association. Many of the graves, such as that of William Augstin Swift and Nancy J. Swift, have elaborate and decorative designs carved on Elberton granite.

Six

CREATING A TRAVEL AND ENTERTAINMENT INDUSTRY

By the end of the 19th century, train travel had become common, and Elbertonians—like other Americans—were on the move. Later, they added bus, automobile, and airplane travel. With this important change of lifestyle and the addition of mobility, the citizens of Elberton built train and bus stations and a small airport.

The transportation industry began in Elberton in the manufacturing sector of production of carriages and buggies, but expanded rapidly with the incursion of train service into the city. The growth of the railroad passenger industry led to the construction of a railroad depot that is still standing in 2002 and has become a model example of historical reuse in its long-term rental to the Elbert County Historical Society as a meeting house, museum, and historic site. Bus service began at the old Sinclair Service Station on the Public Square and continued after 1946 in a new bus station on the corner of Church and McIntosh Streets until its closure in later years The construction of an airport in Elbert County resulted from tireless efforts of many Georgians, including Governor Carl Sanders, who presented the dedication speech opening the airport in 1964.

To accommodate large numbers of visitors arriving in Elberton for business and/or pleasure, private entrepreneurs and civic groups constructed hotels and theatres to provide rooms for their comfort and shows for their entertainment while in the city.

In 1892, Dave C. Smith built an Opera House on the Public Square to provide a place of public assembly and cultural enjoyment for the citizens who had responded to his business efforts and those of his brother W.C. Smith. The Opera House survived until a fire gutted it in 1944, long after it had ceased to function as an Opera House but still contained a movie theatre and many stores. In February 1940, the Lucas and Jenkins developers constructed an Art Deco–style theatre that influenced others, including the Paramount Theatre in New York. After a fire in 1940 and closure in 1966, the Elbert theatre is under restoration as a community theatre in 2002.

The deprivations of the 1930s depression and the World War II years of the 1940s halted the intensive growth and development Elberton had experienced in the late 19th and early 20th centuries. After the end of World War II, however, there followed a quarter-century of new expansion of the city. Added to an infusion of new materials at the end of the war was a new dimension of communication. In addition to newspaper reporting, radio soon became part of the city's daily routine. On January 1, 1947, the radio station WSGC joined The Elberton Star, which was the most enduring of the city's newspapers, to bring news and entertainment to Elbertonians.

In 1899, J.H. Orr, Elberton's premier photographer of his day, portrayed the Elberton Baseball Team. Mrs. Charles P. Ward (the former Reese Adams) owned the photograph, whose identifications include only last names that are not always legible. They include from left to right the following: (front row) Frost, Mitchell, and Accosini(?);(middle row) Brisou(?), Hallan(?), P. Tutt, and Byers; (back row) Crocket, Chambers, Bongston(?), McBride, and McMahan. (Photograph by J.H. Orr, Courtesy of Dr. Robert Patrick Ward.)

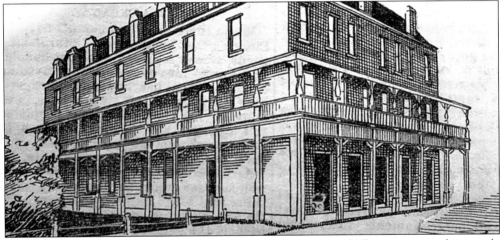

In the midst of rapid growth in the late 19th century, the city of Elberton was so desperately in need of hotel accommodation that an anonymous editorial appeared in *The Elberton Star* on May 8, 1891, proclaiming the serious lack of adequate hotel space. The writer announced that Dr. Nathaniel Gholston Long was prepared to build a luxurious hotel and included a sketch of the proposed hotel Long built in 1892. Many Elbertonians, as well as travelers, considered the Hotel Gholston the most elegant of all hotels in the city. Long later sold the hotel, and many owners managed it until its closure in the mid-20th century and its demolition in 1976. (Courtesy of *The Elberton Star & Examiner*.)

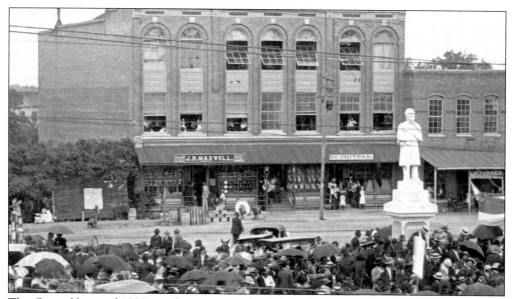

The Opera House of 1892, on the western side of the public square, was a shining star among buildings in the city. Dave C. Smith, with support of his brother W.C. Smith, designed and constructed the Opera House to provide citizens of Elberton with a public meetinghouse comparable to those in larger cities in the state. The opening concert of *La Moscotte* drew large crowds from Athens and other nearby towns. (Photograph by J.H. Orr, Courtesy of Dr. Robert Patrick Ward.)

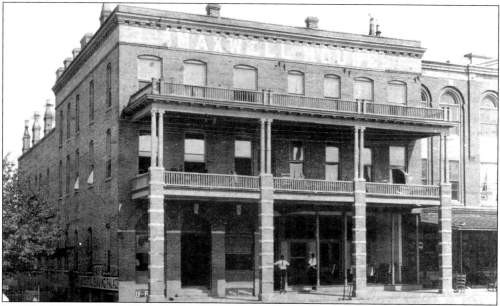

In 1906, William E. Wallis built the Maxwell House for Mr. and Mrs. J.H. Maxwell as a large hotel, which also included a permanent post office and storerooms on the ground floor and workshops in the basement. The hotel provided temporary lodgings for travelers and long-term housing for many new residents of the city. Before she married J.H. Maxwell, Mrs. Maxwell had operated The Simpson House, where she met Maxwell, one of her boarders. After their marriage, they operated The Maxwell House. (Courtesy of Elbert County Historical Society.)

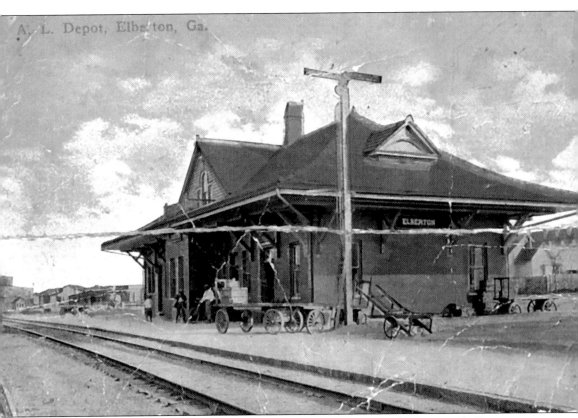

The expansion of railroad travel made proper facilities for travelers essential. Citizen groups in Elberton, led by business leader William O. Jones, petitioned railroad leaders to construct a permanent depot, which became a reality in 1909–1910 with the Seaboard-Airline Railroad Depot constructed by J.J. Kellar & Company of Rock Hill, South Carolina. (Courtesy of the Elbert County Historical Society.)

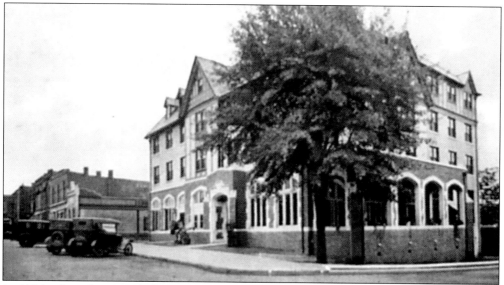

In 1924, when the city of Elberton built the Samuel Elbert Hotel as a community project to provide vitally needed traveling accommodations, the entire community became involved, including high school students who wrote newspaper editorials supporting the campaign for a new hotel. The selected site on the southwest corner of the public square had been vacant for a number of years after being proposed for earlier civic projects, such as a fire station at one point. The Pringle and Smith architectural firm of Atlanta designed the Samuel Elbert Hotel, which was named for the same Revolutionary War hero whose name went to the county and city. In September 1925, the Samuel Elbert Hotel opened with an elaborate ceremony honoring the citizens of Elberton, the building committee, and the achievements of Samuel Elbert. (Courtesy of Ted Dove.)

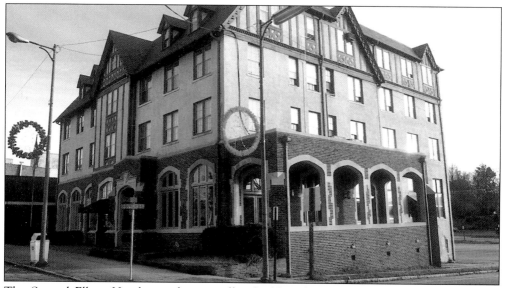

The Samuel Elbert Hotel served as an office building for much of the last quarter-century but is now empty in 2002 and again in search of tenants. The beautiful, historical building stands sentinel on its southwest corner of the square, like the other magnificent buildings at the other corners.

Justice Peyton S. Hawes Sr. (1903–1990), native of Elberton and son of Dr. Albert Sidney Hawes and Julia Cade Hawes, began his political career in 1931, when he was elected to the Georgia House of Representatives. In 1945, be began the first of three terms in the Georgia Senate, where he sponsored mental health legislation. After serving as State Revenue Commissioner from 1967 to 1969, in 1970 he was appointed to complete an unexpired Georgia Supreme Court term, and after his election in 1971, he served as associate justice until mandatory retirement in 1973. Justice Hawes played a significant role in the life of the Samuel Elbert Hotel. During the depression years of the 1930s, Hawes participated in the purchase of the hotel, which had fallen onto bad times, and later became sole owner of the hotel for many years, with the exception of a short period. The hotel is still owned by the family. Throughout his lifetime, Justice Hawes continued to contribute to the civic good and in 1976, became the first president of the newly formed Elbert County Historical Society. Justice Hawes, however, would probably have preferred to be remembered best for his creation of industry in Georgia and his success in bringing the Richard B. Russell Dam to the Elberton community. (Courtesy of Mary Minor Hawes Brown.)

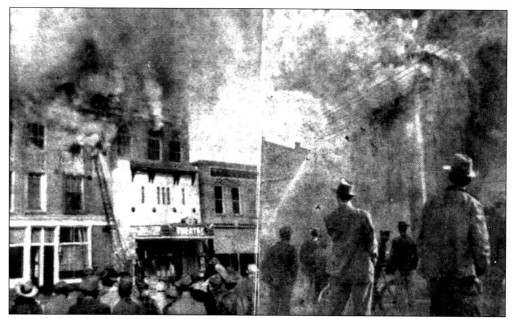

After the first few years of operation, the Opera House began to change its bookings somewhat and feature local affairs, such as high school graduations and public lectures. After Dave C. Smith sold his interest in the business in the early 1900s and moved to the mountains for his health, there were many local users of the building, in addition to those who had opened stores there in the beginning. One of the new businesses to open in the building was the Strand Theatre, which moved into a storefront on the northern side of the building after the old theatre in the Day Block burned in December 1919. In January 1944, a fire erupted in the theatre and burned the entire building, which was not rebuilt because of wartime restrictions on the use of building materials. (Courtesy of *The Elberton Star & Examiner*.)

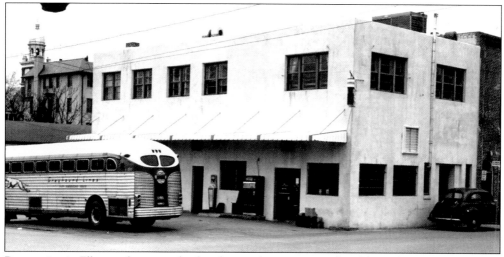

Bus service in Elberton began at the first-known bus station in the old Sinclair Service Station, built in 1933 on the site of the old Jones & Co. store. Then, in 1946, Allen Scarborough constructed a new bus station on the northwest corner of Church and South McIntosh Streets. Scarborough held a contract with the Atlantic Greyhound Company for bus service. (Photograph by Everett W. Saggus, Courtesy of Shirley and Walter McNeely.)

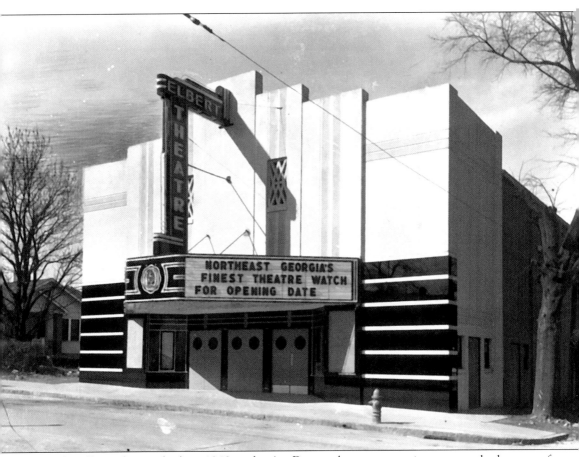

The Elbert Theatre, built in 1940 in the Art Deco style, was a prominent exemplar because of its streamlined shapes and elegant decorative features. For those who loved movies, the padded entrance doors and exterior windows for inserts and one-sheet movie posters evoke memories of special extravaganza films shown in the prime period of Sunday through Tuesday, film noir masterpieces in mid-week, and double features of westerns and adventure sagas on Saturday. (Photograph by Everett W. Saggus, printed by Wil Hall. Courtesy of Wil Hall.)

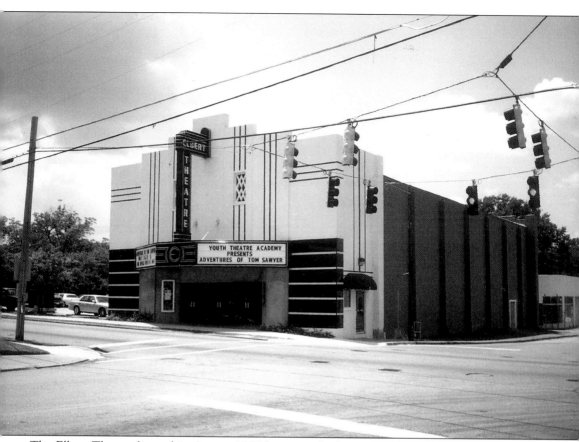

The Elbert Theatre burned in August 1950 but was rebuilt very quickly and opened again in the fall. James M. Hunt was chosen to rebuild the structure in the same style. The new building contained safety features to make it fireproof and air conditioning to add to the comfort of the moviegoers. In 1967, attendance at movies reached a low point; the theatre was sold and turned into a teen facility titled the Taho Club. Later and separate efforts to use the building have resulted in the present Elbert Theatre Foundation, which is restoring the theatre for use as a community theatre, where *The Adventures of Tom Sawyer* appeared in the summer of 2002. The level of restoration in 2002 reveals the return of porthole windows to the entrance doors as part of the ongoing restoration.

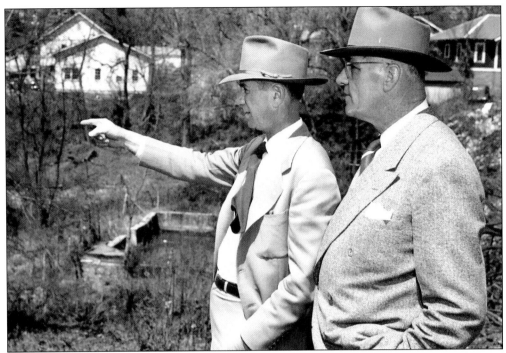

In the early 1950s, Ben F. Sutton, director of the City Park Commission, began plans to convert the swampy ravine behind the courthouse around the original spring that had spurred the creation of Elberton into an athletic park. Here, Sutton appears with J. Porter Davis, local business and civic leader. The ravine held remnants of old tanning businesses and excessive plant growth after decades of non–use and created a significant challenge to Sutton. (Photograph by Everett W. Saggus, Courtesy of Shirley and Walter McNeely.)

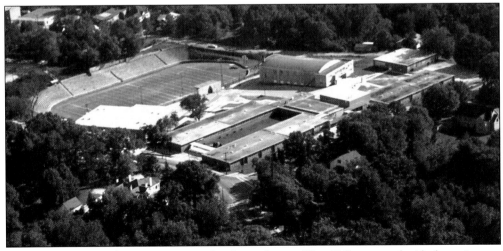

By 1954, the City Park Commission, under the guidance of Ben F. Sutton and with the assistance of granite companies and volunteer football boosters, transformed the swampy ravine into the Granite Bowl for high school football games. It has served as the football field for Elberton High School, Elbert County High School, and Elbert County Comprehensive High School games since. (Photograph by Everett W. Saggus, Courtesy of Shirley and Walter McNeely.)

In 1946, the city added a new communications system with the establishment of the WSGC Radio Station owned by Harry G. Thornton, Gradus T. Christian, and John L. Barnes on Jones Street. Broadcasting began on January 1, 1947, as WSGC. An unidentified individual leaves the station during the early days of the construction. (Courtesy of *The Elberton Star & Examiner*.)

A half-century ago, Elbert County students in the seventh grade earned a day off and traveled at the courtesy of the County and Shriners to the Shrine Circus in Atlanta. Here, the group line up for the trip around 1954. (Photograph by Everett W. Saggus, Courtesy of Shirley and Walter McNeely.)

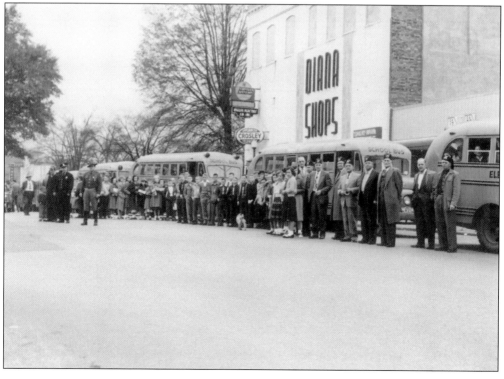

Dr. Nathaniel G. Long established the first telephone system in Elberton in the late 19th century, which formed the basis of the system controlled by Southern Bell Company. In later years, The Southern Bell Telephone & Telegraph Company operated in a small brick building on Heard Street until construction of the local dial and business office on North Oliver Street in 1961. Martha Clark Fowler, shown with an unidentified operator, served as a telephone operator in the Elberton office on Heard Street. (Photograph by Everett W. Saggus, Courtesy of Shirley and Walter McNeely.)

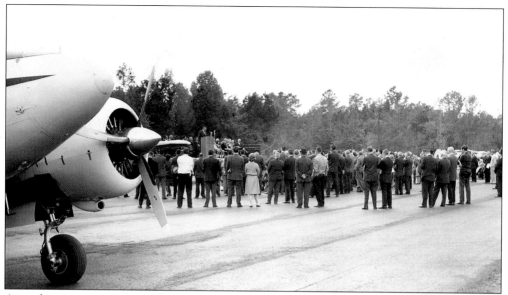

At mid-century, citizens in Elberton began planning an airport. The efforts of many, including Gov. Carl Sanders, were focused on making government funding available for an airport in Elbert County. This became a reality in the early 1960s, with the construction of Patz Field, which was built on a site off the Calhoun Falls highway, Highway 72 East. With grants received in 1963, construction began; the airport opened in 1964. (Photograph by Everett W. Saggus, Courtesy of Shirley and Walter McNeely.)

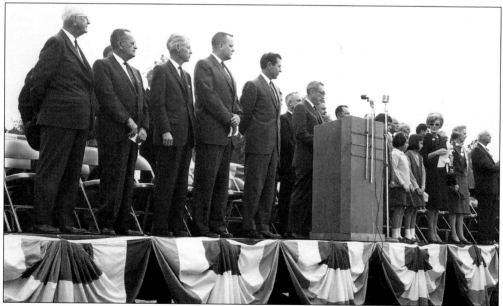

The new Elberton airport was opened in September 1964 and dedicated as Patz Field to the late Louis Patz, who lost his life in an air crash during an art tour to France in 1962. Members of the platform party include, from left to right, the Rev. George O. King, Joe Allen, Mayor John Harris Bailey, Dr. John B. O'Neal III, Gov. Carl Sanders, Robert E. Lee Jr. at the podium, and members of the Patz family. (Photograph by Everett W. Saggus, Courtesy of Shirley and Walter McNeely.)

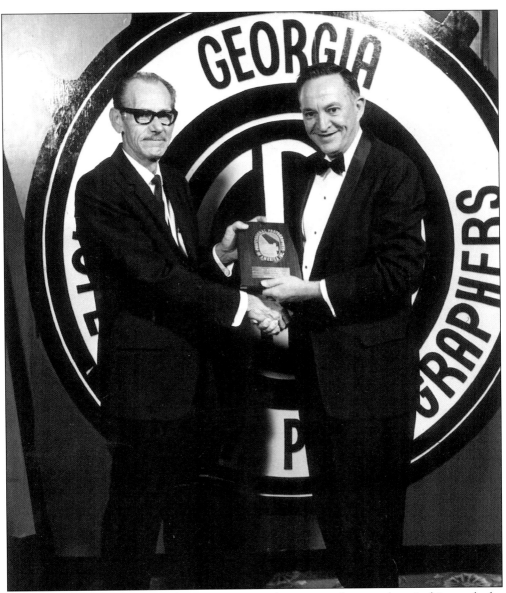

Everett W. Saggus (1910–1979) was an artist and a master photographer. In his youth, he painted artistic posters for the Fox Theatre in Atlanta, where his love of all things related to movies and film theatres allowed him expression. Later, in 1942, after working for a brief period in Warrenton, Georgia, Saggus moved with his wife and daughter Pegge to Elberton. Here he rented the photography studio in the Jones Building from Mrs. L.C. Arnett, who had purchased it from N.D. Taylor a short while earlier. After renting the studio for a few months, Saggus purchased it and embarked upon his long career of photographing Elberton and Elbertonians. He is fondly remembered by generations of Elbertonians for his remarkable photographic record of their city and the changes it experienced in the nearly four decades Saggus profiled it for them. Here, Saggus accepts the Professional Photographers of America Award from Furman Bisher; however, the most distinguished of his many awards was the prestigious Master of Photography Award, which was special because only a limited number of photographers earn it and because it rewards a large body of work. (Courtesy of Shirley and Walter McNeely.)

Seven

SALUTE TO
HEROIC CITIZENS

Memorials to honor human achievement of Elbertonians consist of military monuments to the heroic living and dead, national and regional anniversaries, and memorials honoring individual achievement and fame.

Elbertonians have honored their military heroes and have paid tribute to the themes of glory and respect wherever possible. The first Elbert County Memorial to the Civil War veterans was unveiled July 15, 1898, in special recognition of Elberton's entry into the conflict. On July 15, 1861, the 15th Georgia Regiment marched from Elberton to war and an uncertain fate. The fate of the first monument dedicated to their cause was similar. The statue unveiled that day stood two years before falling to the ground, as many Elbert County soldiers had before him. The second memorial replaced the unfortunate first one in 1905. A later and more successful military memorial was the Elbert County Military Park on North Oliver Street, which contains monuments to the veterans of all wars involving Americans.

In addition to military monuments, the American Eagle Bicentennial Monument on the public square is a dynamic granite structure, and the Grady Albertson Spire competes successfully with obelisks erected by Egyptian rulers to show power. The most famous Elberton monument of the last quarter century, however, is the Georgia Guidestones monument on Highway 77 North, in which massive granite megaliths redefine an image of prehistoric times.

The granite of Elberton is used largely for monuments, and Elbertonians have taken advantage of it to produce monuments for Elberton, about Elberton, and for export to the rest of the world. The granite industry of Elberton helps to define the history and the legacy of the small town begun near a spring and continued inside the crevices of many granite quarries. In 2003, Elberton will celebrate its 200 years of glory, success, as well as loss and failure. The optimism and goodwill of its leaders will carry it well into the next century. The story of Elberton, as well as the story of the granite and all other resources of the city, both human and inanimate, will continue well into the next century for the celebration of the tricentennial in another 100 years.

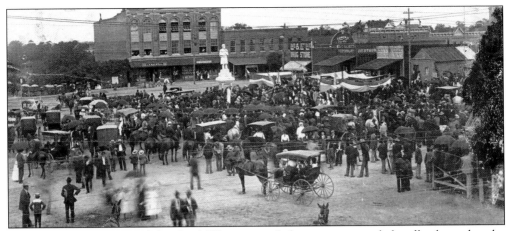

Elbert County veterans of the Civil War received their monument belatedly three decades after the war ended. Fund-raisers for a memorial statue included a Monument Fair in 1891 and the successful campaign of the Memorial Association, headed by Mrs. Robert M. Heard as president, which commissioned a granite figure from Arthur Beter. The unveiling of the statue on July 15, 1898, was the highlight of a day of celebration marked by parades, speeches, and flag ceremonies. Following a parade from the Elbert County Courthouse to the Harris-Allen Library & Masonic Lodge, Louise McIntosh presented the Confederate flag to her cousin Robert M. Heard, a wounded veteran, who accepted the flag on behalf of his comrades and vowed that the flag would never trail in the dust. The party moved on to the statue for the Masonic ceremony in the center of the public square, where Col. John P. Shannon presented building tools to Dr. Nathaniel G. Long, Grand Architect of the Masonic Lodge. Roberta Heard unveiled the monument. (Photograph by J. H. Orr. Courtesy of Dr. Robert Patrick Ward.)

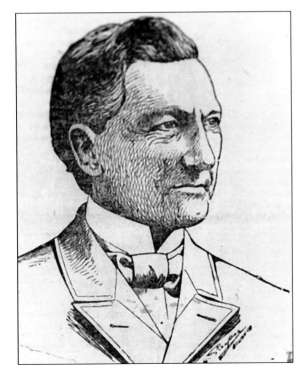

Gen. Clement A. Evans, who had commanded southern troops in the Civil War, spoke at the unveiling of the Civil War monument and complimented the statue, those who had made it possible, and the soldiers who had served in the war. (Courtesy of *The Elberton Star & Examiner*.)

The Confederate statue unveiled July 15, 1898, was different in pose, style, and general appearance from this illustration that appeared in *The Elberton Star* during the week of the unveiling, although there was no reference to these differences. By 1900, there was some dissatisfaction with Arthur Beter's Civil War monument then being called "Dutchy" because of his perceived appearance of a northern soldier from the Pennsylvania "Dutch" (really *Deutch* or German) country or the Dutchman, as James McIntosh referred to the figure. The statue had fallen into such disfavor by 1900 that on a dark night in August, some unidentified individuals knocked it down and broke the legs. Authorities quietly buried the statue. (Courtesy of *The Elberton Star & Examiner*.)

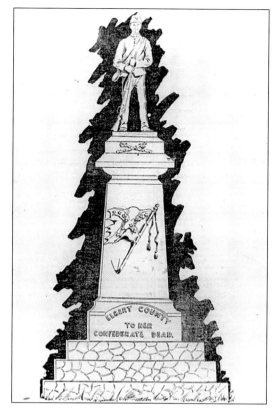

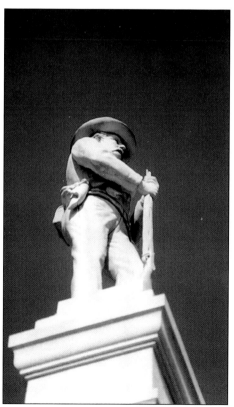

By 1904, the newly formed Stephen Heard Chapter of the DAR, dismayed by the absence of a Confederate memorial, succeeded in creating a committee to replace the fallen statue. Consisting of Edmund Brewer Tate Jr., William P. Clark, and W.B. Adams, the committee commissioned a new statue in white bronze, a material that resembled marble, from the White Bronze Company of Bridgeport, Connecticut, for $500. The statue was installed quietly in April 1905.

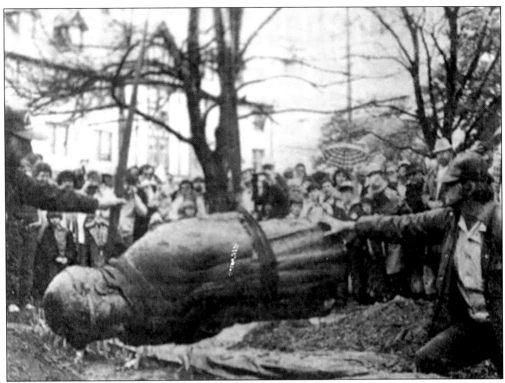

In 1982, the Elberton Granite Association exhumed the original Confederate statue from its 82-year old grave. The statue, still known as Dutchy, but held in more affection among Elbertonians in 2002 than in 1900, is on display at the Elberton Granite Museum & Exhibit. (Courtesy of *The Elberton Star & Examiner*.)

The face of Dutchy is a portrait of simple forms. Portrayed here as if standing, in reality, Dutchy is on display on its back because the legs were broken when it was dismantled in 1900.

The Bicentennial Eagle Monument of 1976 was the product of the industrious efforts of the Elberton Granite Association, Inc, many granite companies, the city and county governments, the Elberton-Elbert County Bicentennial Committee, and a number of interested citizens. The Eagle proudly represents two centuries of American life, and the surrounding base bears inscriptions showing the part played by Elbertonians in the life of the young country.

The Grady Albertson Spire is a tall vertical granite block, whose dimensions inspire comparisons with granite obelisks of ancient Egypt. In 1975, Grady Albertson transported the 51-foot, 41,810-pound spire from the Peppers Granite Company to John Brown's yard for finishing and then to Argo Trucking Company on Elbert Street, where it was set on a prepared base. Later, in 1980, he moved it to the Granite Plaza of the Elberton Granite Association, Inc., on College Avenue. Albertson's friends named the spire for the brilliant truck driver and dedicated it to him.

The Tate and Miller families created the Elbert County Veterans Park to honor Elbert County veterans of all wars. In 1921, following the death of E.B. Tate II in France during World War I, his parents donated land on North Oliver Street for a memorial park to all casualties of the war. Tate's aunt Carrie Sophia Tate and the Service Star Legion (a club formed to honor the Elbert County war dead) expanded the park and memorial; the growth has continued to include monuments to the Elbert County veterans of all wars. Tate's niece, Carolyn Miller, continues to monitor projects for the park, which the family donated to Elbert County.

The mysterious Georgia Guidestones erected in 1980 in an isolated setting in Elbert County compete in format with the famous Stonehenge monument of Salisbury Plain, England. The designer/patron of the Georgia Guidestones monument is unidentified, but many local granite artisans carved inscriptions and patterns on the stones. Messages written in major world languages evoke sentiments of conservation and world peace, and astronomical functions abound in openings in the vertical slabs of granite. The slabs are approximately the same size and scale as those at Stonehenge, although the arrangement and purported meanings are different. The monument, which sits in an open field off Highway 77 North on the way to Hartwell, Georgia, is a popular tourist attraction and has stirred speculation and controversial interpretation not unlike those proposed for Stonehenge. Altogether, the monument provides a spot to pause and reflect upon the eons of time required by the earth to produce this granite and the 200 years of history in Elberton, which granite has made famous all over the world.